Postcard History Series

# Charleston

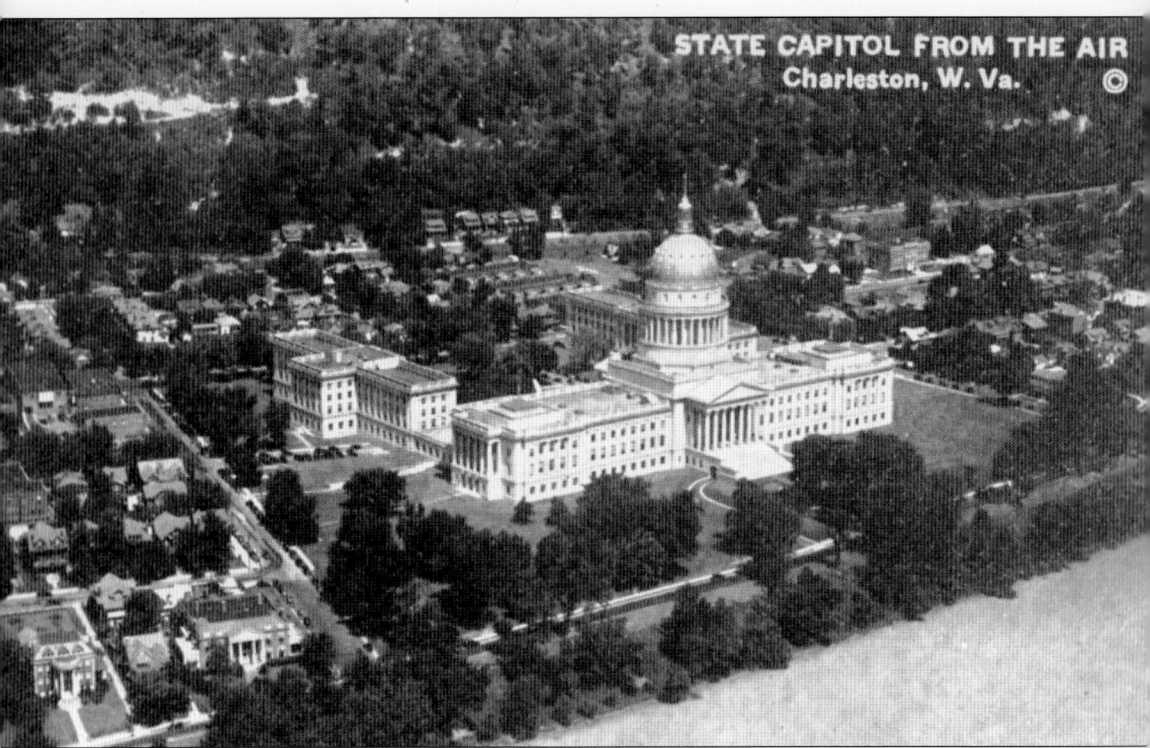

STATE CAPITOL. This 1930s aerial view of the East End shows Kanawha Street before it was widened into a four-lane boulevard. The capitol complex consisted only of the statehouse, while Duffy Street separated the capitol and the governor's mansion. In the bottom left is Charleston's oldest building, Holly Grove, the 1815 house of pioneer Daniel Ruffner.

ON THE COVER. This 1918 view of Capitol Street was taken just north of Fife Street (now Brawley Walkway) looking south. The newly built Kanawha Banking and Trust (KB&T) building and the Union Building are in the distance. On the right (front to back) are the Colonial Theatre, F. W. Woolworth's, and the old Charleston National Bank.

Postcard History Series

# *Charleston*

Stan Bumgardner

ARCADIA
PUBLISHING

Copyright © 2006 by Stan Bumgardner
ISBN 978-0-7385-4265-2

Published by Arcadia Publishing
Charleston SC, Chicago IL, Portsmouth NH, San Francisco CA

Printed in the United States of America

Library of Congress Catalog Card Number: 2006920982

For all general information contact Arcadia Publishing at:
Telephone 843-853-2070
Fax 843-853-0044
E-mail sales@arcadiapublishing.com
For customer service and orders:
Toll-Free 1-888-313-2665

Visit us on the Internet at www.arcadiapublishing.com

*To Mary Beth and Guy, with all my love*

# Contents

| | |
|---|---|
| Acknowledgments | 6 |
| Introduction | 7 |
| 1. The First Charlestonians: Prehistory–1863 | 9 |
| 2. The Capital City: 1863–1885 | 13 |
| 3. A Modern City: 1886–1919 | 21 |
| 4. A Suburban City: 1920–1949 | 81 |
| 5. A Time for Urban Renewal: 1950–Present | 109 |
| 6. Changing Landscapes | 117 |
| Index | 124 |

# Acknowledgments

I want to thank the Kanawha Coin Shop for loaning me all the postcards used in this book. My father, Doug, who owns the shop, and my mother, Rena, always have encouraged my love of history.

I need to thank the Kanawha County Circuit Clerk's Office, Kanawha County Public Library, South Charleston Public Library, South Charleston Museum, West Virginia State Historic Preservation Office, and especially the West Virginia State Archives, whose staff pulled dozens of Charleston directories and literally thousands of newspaper clippings for me. David Hendrickson, Richard Andre, and Richard Davis also provided helpful information.

I am grateful to Mary Beth Gurski, Christine Kreiser, Ginny Painter, and my father for taking the time to read the manuscript and suggest much needed changes. I also would like to thank my editor, Lauren C. Bobier, who demonstrated great patience in answering my many questions.

Above all, I would like to thank my wife, Mary Beth, and son, Guy, for their continual love and support. I owe them a special debt of gratitude for putting up with me at home for two months. You can have your computer back now, Guy.

# INTRODUCTION

*Location, resources, and fortuitous circumstances made Charleston not only the commercial and cultural center of the valley but also the capital of West Virginia.*
—Historian Otis Rice, *Charleston and the Kanawha Valley*

The story of Charleston, West Virginia, is like no other. It was the second and fourth capital of the only state created by the Civil War. Few cities can match Charleston as a transportation crossroads, first as an intersection for frontier turnpikes, then as a railroad hub, then as a shipping lane, and finally as a connecting point for three interstates. In addition, Charleston has retained a small-town appeal while blossoming from a frontier village into a corporate center for the coal, oil, gas, timber, and chemical industries.

This book tells the story of how Charleston's distinct appearance developed over time. In a sense, it is the biography of a place. The history of a city, like the story of a person, demonstrates a clear life cycle of growth and decline. A place, just like an individual, faces life-changing moments that alter its course forever. These postcards of buildings, businesses, transportation routes, and parks depict how Charleston continually has adapted to changing times.

The key issue, then and now, has been how to calculate the value of the old versus the new. When should older buildings give way to modern developments? City leaders constantly are faced with the debate of demolishing the old to make improvements. This requires a shared understanding of the elements that define Charleston—in other words, what makes Charleston the place it is.

The way Charleston looks today has not been a gradual development. It mostly occurred during several relatively brief periods of reinvention. Much of this book focuses on the formative period between 1885 and 1920. A 20-year-old who arrived in Charleston in 1885 most likely had never used a telephone, ridden on a streetcar, or even heard of electricity. By the time that person had turned 55 in 1920, traffic jams were becoming common, airplanes flew from the Kanawha City airfield, and Charleston had 10 movie theaters. Regardless of the technological advances of the late 20th century, it is hard to imagine a 35-year stretch of American history when things changed more. During this period, downtown Charleston began developing the look it would retain until the late 20th century.

In writing a Charleston history told through postcards, the one limitation is the postcards themselves. I tried to relate as many stories as possible through the available postcards; however, I was unable to locate images of particular sections of town and some well-known businesses, such as Stone and Thomas or Woodrum's. In addition, postcards of the early 20th century largely

excluded sites that represent different ethnic or racial groups. In that sense, this book is not a comprehensive history of Charleston. For a more complete picture, I encourage everyone to read both of Stan Cohen and Richard Andre's volumes of *Kanawha County Images* and John Morgan and Robert Byers's *Charleston 200*. Tom Dunham's *Charleston in the 20th Century* is another fine book that shows how Charleston evolved as a city. I also owe a debt of gratitude to all other past and present authors of Charleston history: John P. Hale, William S. Laidley, George Summers, Roy Bird Cook, Julius de Gruyter, Simon Meyer, Otis K. Rice, James Randall, Anna Gilmer, and Paul Marshall, to name just a few.

# One

# THE FIRST CHARLESTONIANS
## *Prehistory–1863*

Rivers, fertile farmland, and mineral resources have attracted people to the Kanawha Valley since the beginning of human existence. Prehistoric people first arrived in the Kanawha Valley at least 12,500 years ago, although relatively little is known about them. By the 16th century, Late Prehistoric cultures lived in planned circular villages. Archaeologists have discovered evidence of these villages at Marmet and Buffalo. European explorers, who arrived in the late 17th century, found only abandoned villages, suggesting the prehistoric settlers had moved west; however, explorer Gabriel Arthur claimed to have visited a village of Moneton Indians in the Kanawha Valley in 1673. By the 18th century, Native Americans no longer lived in the valley but still used the area for hunting.

In April 1788, George Clendenin led the first group of permanent white settlers to Charleston. To protect themselves against Native Americans, these early Charlestonians built Clendenin's Fort near the present intersection of Kanawha Boulevard and Brooks Street. In 1792, the fort was renamed Fort Lee. The threat of Native American attacks diminished shortly thereafter, and the fort was abandoned.

Although Charleston became a town in 1794, it remained mostly a frontier outpost until a salt-industry boom in the early 19th century. When the War of 1812 cut off British salt supplies, the salt operations at Kanawha Salines (present Malden) filled the void and soon led the nation in production. Many salt operators built majestic houses in Charleston. Their names are synonymous with Charleston history—Ruffner, Dickinson, Donnally, Noyes. This influx of capital created a demand for banking. In 1832, a branch of the Bank of Virginia was built on the northwest corner of the present Capitol Street and Kanawha Boulevard intersection.

When West Virginia entered the Union in 1863, Charleston was the state's fourth-largest city with a population of less than 2,000. The state's capital of Wheeling had more than nine times as many residents.

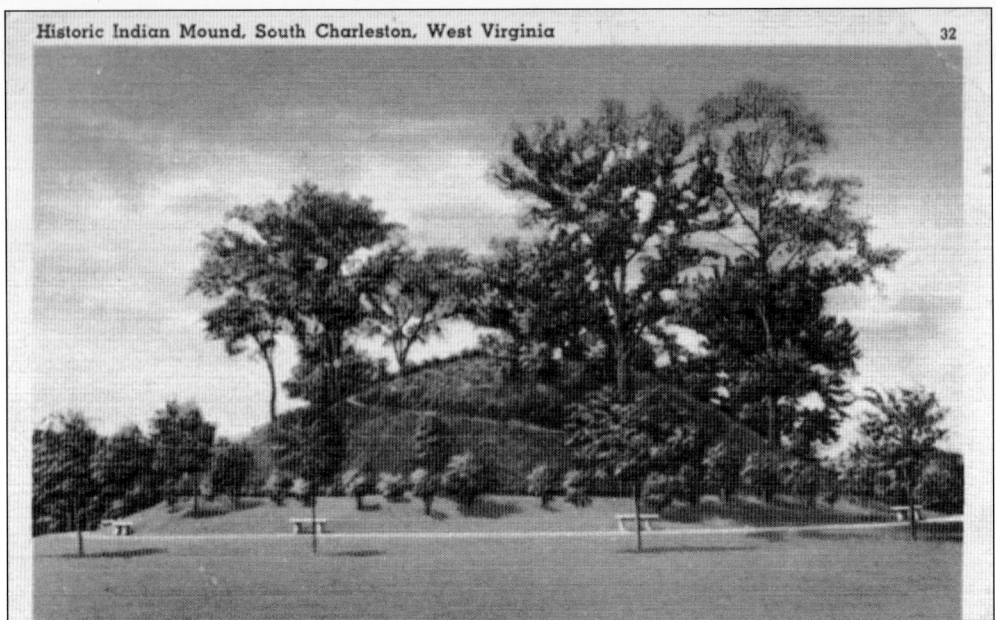

**SOUTH CHARLESTON MOUND.** From about 2,500 to 2,000 years ago, Early Woodland Indians, known in this region as Adena, built numerous earthen and stone burial mounds in the Kanawha Valley. The South Charleston Mound—the state's second largest—is one of the few that remain. The Smithsonian excavated the South Charleston Mound, sometimes known as the Criel Mound, in 1883–1884 and removed a number of Adena skeletons.

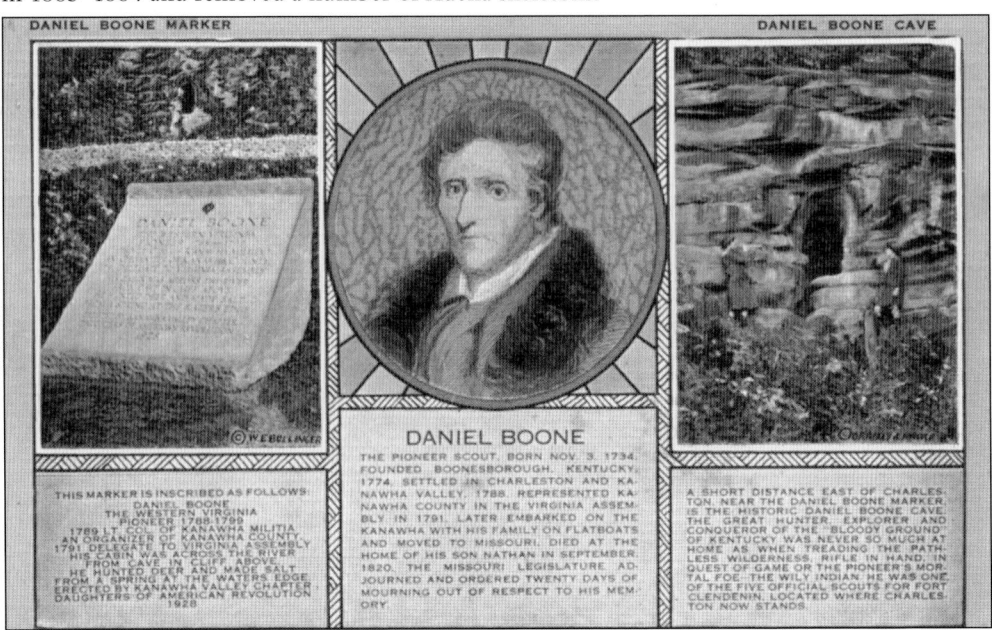

**DANIEL BOONE.** One of Charleston's earliest white settlers was Daniel Boone. In the 1790s, he lived in a cabin near the present intersection of Kanawha Avenue and 57th Street in Kanawha City. He served as a lieutenant colonel in the local militia that protected Fort Lee. As a Kanawha County legislator, Boone pressured the Virginia General Assembly to create the city of Charlestown in 1794 (shortened to Charleston in 1818).

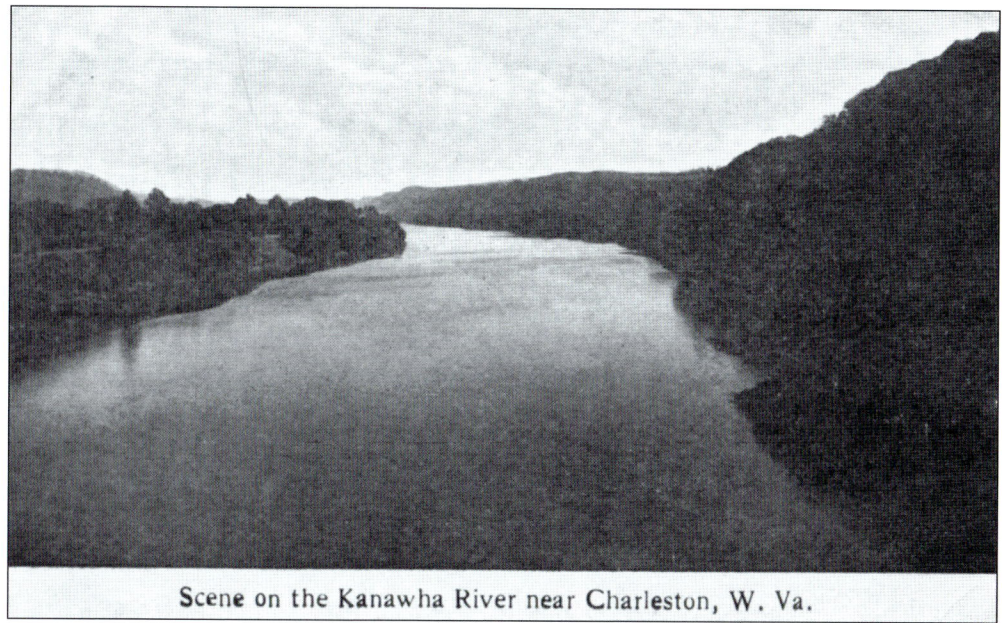

Scene on the Kanawha River near Charleston, W. Va.

**KANAWHA RIVER.** Transportation was the key to Charleston's early existence. The confluence of two rivers—the Kanawha and Elk—made the city a natural shipping center for the valley's burgeoning salt industry; however, shallow points made river travel hazardous. Charleston would not begin to realize its true commercial shipping potential until a series of locks and dams were completed in the 1880s.

**JAMES RIVER AND KANAWHA TURNPIKE.** Charleston's first stately houses were built along Front (later Kanawha) Street. Stagecoach traffic picked up when this road was extended to Guyandotte as part of the James River and Kanawha Turnpike. Many of Charleston's houses doubled as taverns or inns for weary turnpike travelers. In the 1830s, Charleston became a transportation hub, including new roads to Point Pleasant and Ripley.

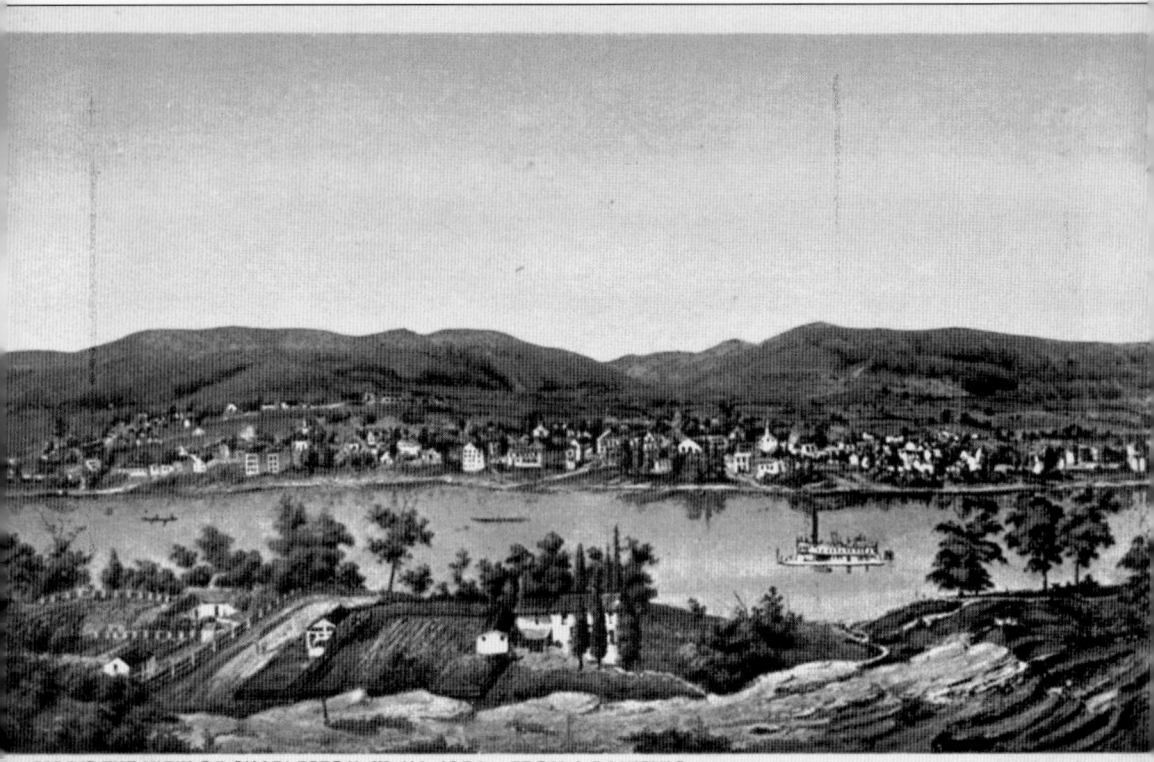

BIRD'S EYE VIEW OF CHARLESTON, W. VA. 1854.  FROM A PAINTING.

**CHARLESTON, 1854.** This Edward Beyer painting provides a rare look at Charleston, Virginia. Most of the town's population was centered along Front (later Kanawha) and Virginia Streets. Today's most heavily populated sections—downtown Charleston, the West Side, and South Hills—largely had not been settled. On the near side of the river, the road on the left led to Goshorn's Ferry. This and Wilson's Ferry at the foot of current Capitol Street provided the only means of crossing the Kanawha River. Another ferry crossed Elk River near the location of the current Kanawha Boulevard bridge. All the farmland in the distant right was owned by the Ruffner family, descendants of the city's earliest white settlers. Although Charleston was not a large slaveholding region compared to eastern Virginia, the Ruffners and many other wealthy families owned enslaved African Americans. Charleston still looked very much like this in September 1862, when Union and Confederate forces pitched the only Civil War battle in the city. The conflict was won decisively by the Southern troops.

# Two

# THE CAPITAL CITY
# *1863–1885*

When West Virginia entered the Union in 1863, Wheeling was the state capital. The new state lacked a capitol building, forcing officials to establish most government offices at Linsly Institute in Wheeling. For six years, officials failed to fund a building dedicated solely to the purposes of state government. In January 1869, Charleston's city council offered the state $50,000 to move the capital from Wheeling. Legislators accepted the council's proposal as part of a political deal favoring the predominantly Democratic city of Charleston over Republican-dominated Wheeling.

Charleston officially became the state capital on April 1, 1870. State officials worked in temporary accommodations until 1871, when the new capitol building was finished on Capitol Street between Lee and Washington Streets.

The capital's initial stay in Charleston was short-lived. Frustrated by the city's muddy roads and lack of hotels, legislators voted in 1875 to return to Wheeling. The loss of the capital pointed out in striking terms that Charleston was behind the times. The city invested more vigorously in infrastructure and installed gas streetlights. After a fire destroyed the main business block on Front Street (now Kanawha Boulevard), businessmen rebuilt bigger and better establishments.

Legislators had grown tired of the capital moving every few years and ordered a referendum to determine a permanent site. On August 7, 1877, state voters selected Charleston to become the new capital beginning in 1885. Anticipating the growth potential, people and businesses began pouring into Charleston; between 1860 and 1880, the population nearly tripled. After the capital moved for the last time in 1885, Charleston began to resemble a modern city.

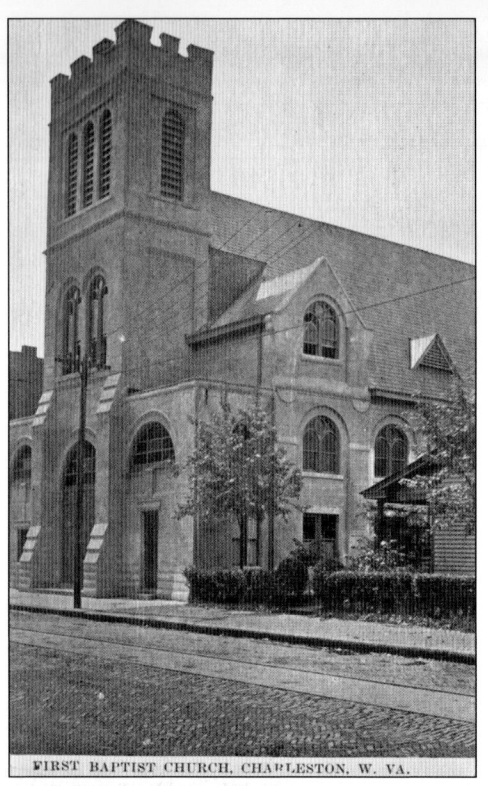

**FIRST BAPTIST CHURCH.** In 1871, African Americans built the First Baptist Church on Washington Street—the site of the current post office parking lot. The congregation erected this more substantial structure around the original church in the 1890s. In the 20th century, First Baptist, under minister Moses Newsome, became a leader in the civil rights movement. The congregation moved to a new building at Lewis and Shrewsbury Streets in 1959, and the old church was torn down.

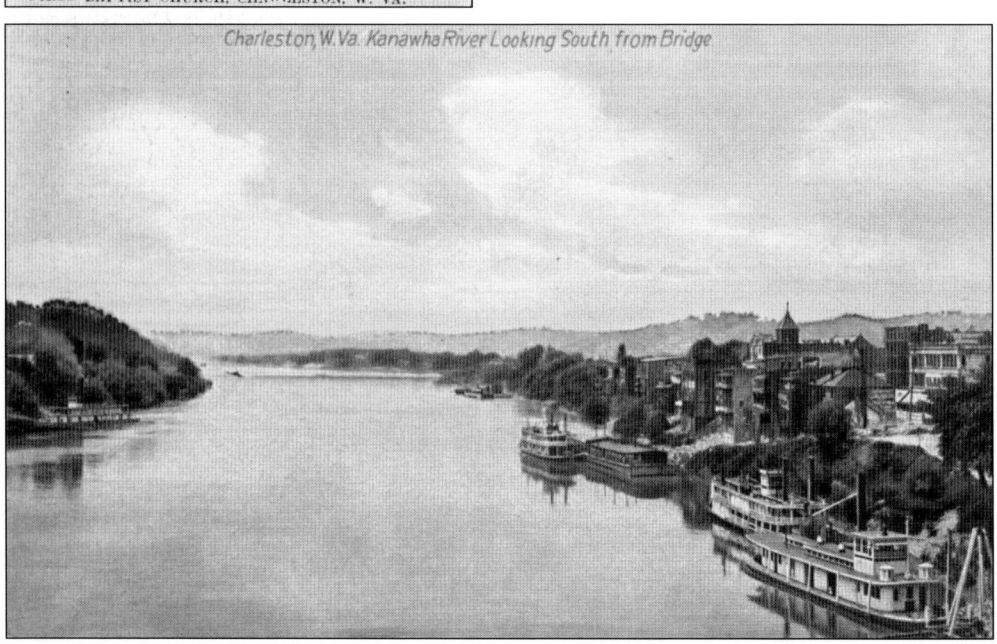

**WARD ENGINEERING.** Charles Ward founded his boat-building business in downtown Charleston in 1872 but soon relocated to the south side of the Kanawha River. A world leader in ship building for decades, Ward Engineering went out of business in 1931. The tugboat on the far left is moored in front of Ward Engineering's factory, and the *James Rumsey* tugboat in the bottom right also was made by Ward.

**THE C&O.** Despite a national depression, 1873 was a turning point for Charleston. The Chesapeake and Ohio (C&O) Railway was completed through Charleston, connecting Norfolk, Virginia, with the new city of Huntington. The C&O ran parallel to the Kanawha River on the south side, with a depot established opposite Charleston's main business district. More than any other factor, the C&O was a catalyst for Charleston's economic development.

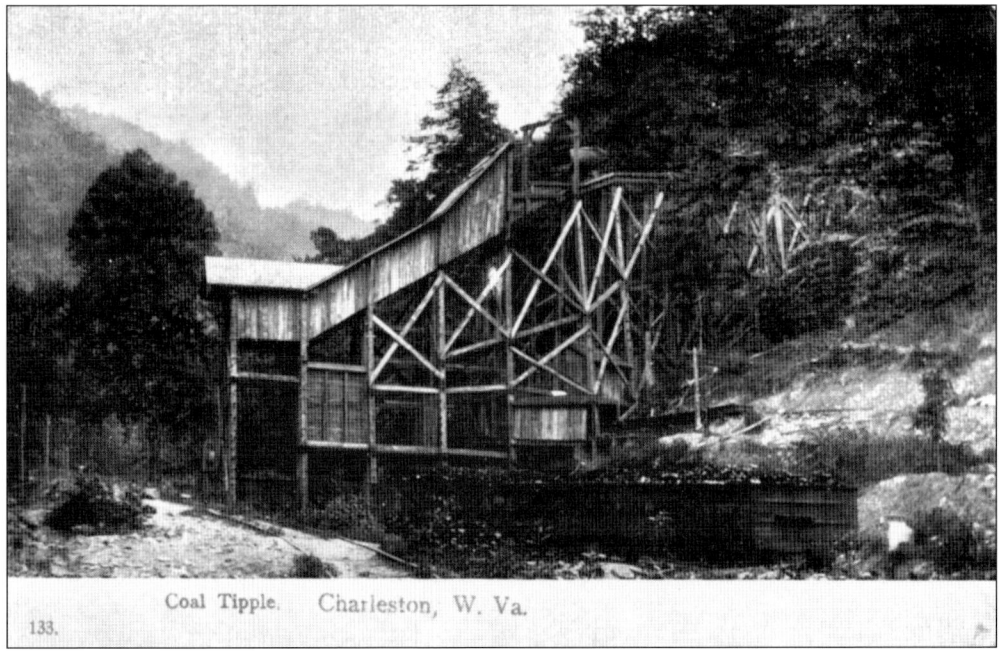

**THE COAL INDUSTRY.** The completion of the C&O and spur lines enabled companies to transport coal from rural places to market. Some small coal mines were located within Charleston city limits; however, the tipple pictured in this postcard—despite the card's claim of being in Charleston—more likely was in a nearby community such as Putney.

15

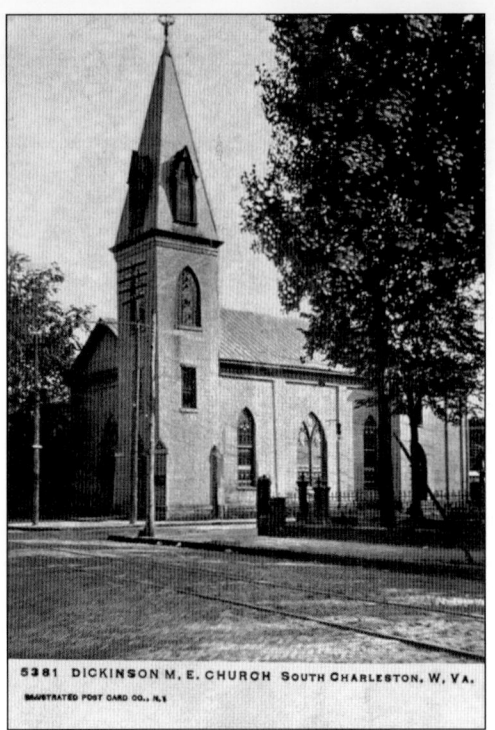

**DICKINSON CHAPEL.** Methodists formed Charleston's first documented church in 1804. Like other denominations, the Methodists split along North-South lines before the Civil War. The Southern Methodists built a church on the southeast corner of Capitol and Virginia Streets, but it was destroyed by Union troops during the war. In 1874, the congregation acquired this lot and built a church on the southeast corner of Dickinson and Washington Streets—the current post office location.

**ST. MARKS UNITED METHODIST CHURCH.** In 1912, the Southern Methodist congregation moved across the street from Dickinson Chapel into this building. After Methodist factions united nationally, the First Methodist Episcopal Church, South, became St. Marks Methodist Church in 1939 and St. Marks United Methodist Church in 1968. Today the building serves as a house of worship and as the Good Samaritan Clothing Center, part of the Covenant House program for the city's homeless and working poor.

**FIRST BRICK PAVEMENT.** In 1873, the first block of Summers Street became the first brick-paved road in the world. The idea was the brainchild of John P. Hale, who realized muddy roads could drive away businesses and even the state capital. He worked with local engineer Mordecai Levi, who covered dirt arches with oak boards, sand, and brick. The closest building on the left of this 1906 postcard was the laundry of Woo Jan, one of the city's first Chinese immigrants.

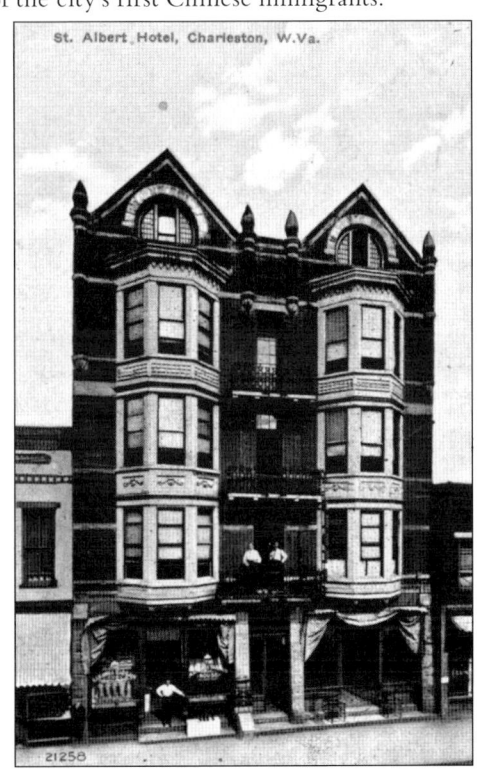

**ST. ALBERT HOTEL.** The St. Albert Hotel is an easily recognizable fixture in early Charleston photographs. It opened on Kanawha Street between Court and Alderson (now Laidley) Streets in the early 1870s. After a fire, the building was remodeled in 1877. It originally was considered one of Charleston's leading hotels but gradually fell into disrepair. It was destroyed by fire in 1932. The city parking garage is now on this site.

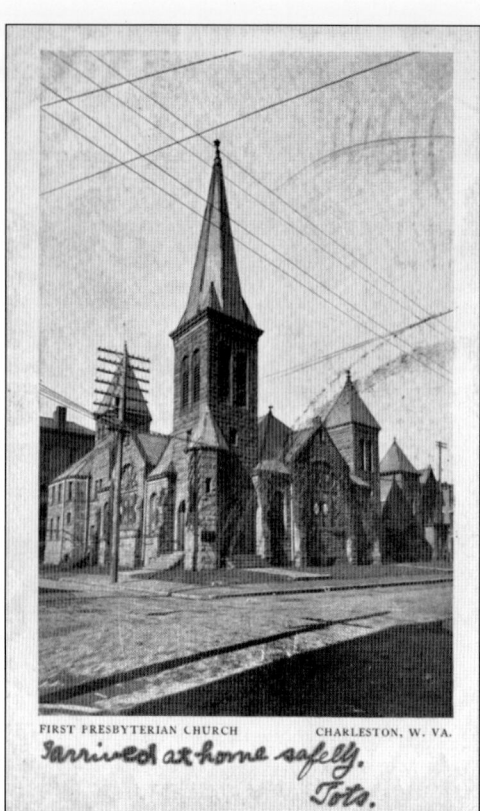

## First Presbyterian Church.

Charleston's earliest Presbyterian church was formed in 1819. When the church split during the Civil War, the congregation broke ties with both the Northern and Southern presbyteries. In 1872, Charleston parishioners split the church between the old Kanawha Presbyterian (former pro-Union supporters) and the new First Presbyterian (former pro-Confederates). The First Presbyterian congregation continued to meet in the old church until constructing this building on the southwest corner of Quarrier and Hale Streets in 1883.

## Kanawha Presbyterian Church.

After the split, the Kanawha Presbyterian congregation began the process of building a new church on Virginia Street between Dunbar and Broad Streets; meanwhile the congregation met in the capitol senate chamber and the former Methodist Asbury Chapel. Financial problems continually hampered construction, while membership dropped to 16. The Kanawha Presbyterian Church was finally dedicated on April 25, 1885. It is Charleston's oldest church building.

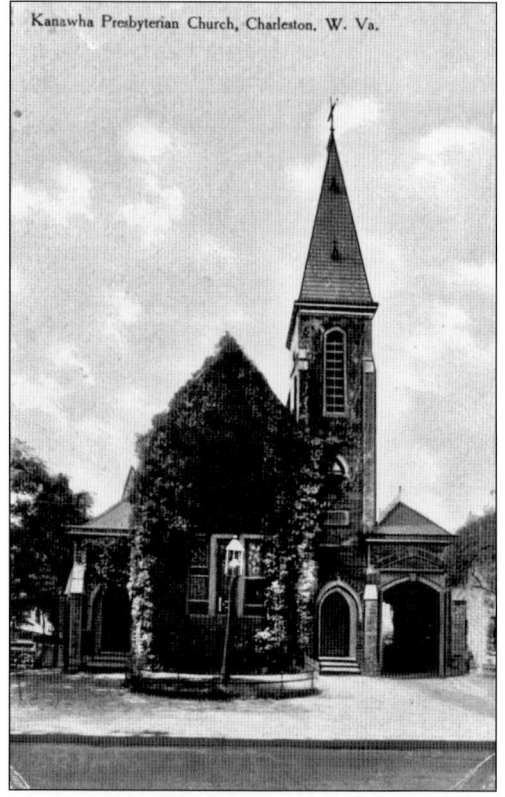

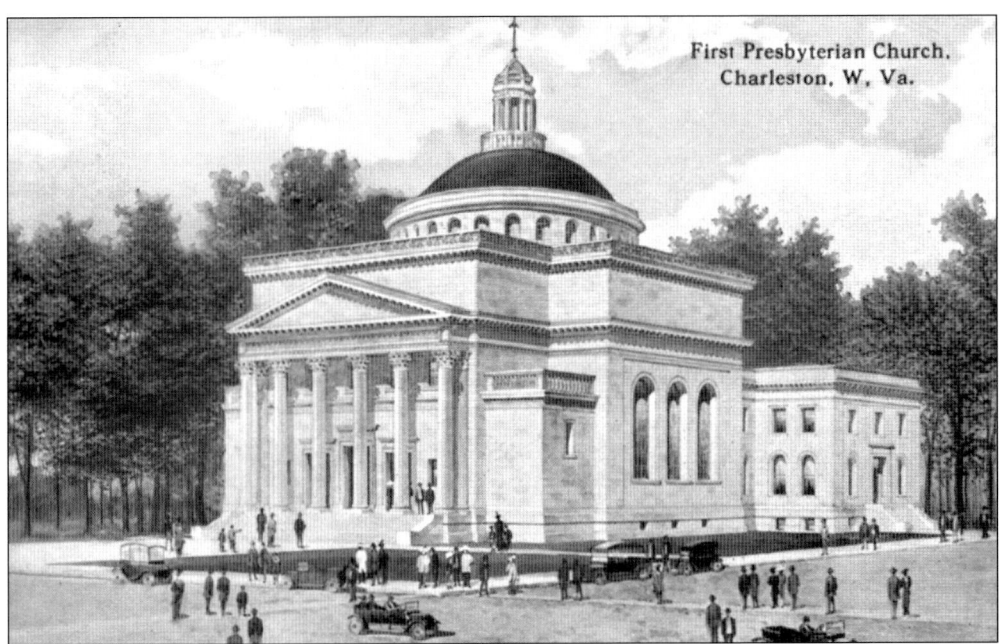

FIRST PRESBYTERIAN CHURCH. The Southern Presbyterians built this church at the corner of Virginia and Broad (now Leon Sullivan Way) Streets in 1915. The exterior of the building was almost an exact replica of the Madison Square Presbyterian Church in New York. An activity building later extended the church to Kanawha Boulevard. The church remains in service and is home to the Covenant House's Food Pantry.

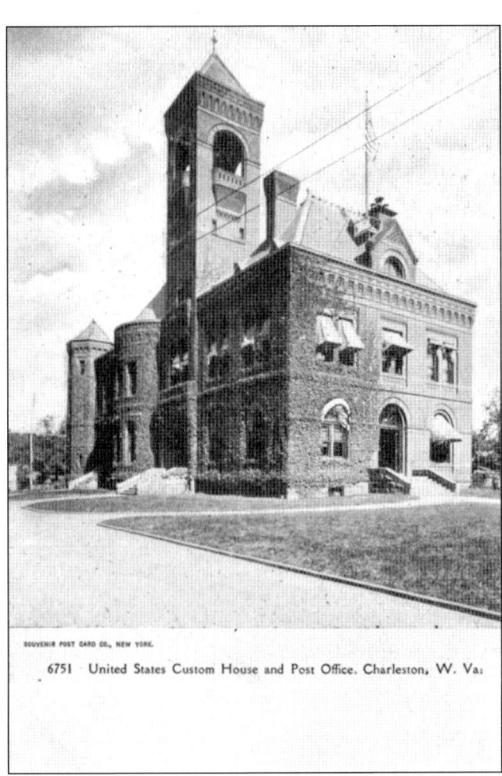

U.S. CUSTOMHOUSE. In 1884, a federal customhouse was completed on the site of the current public library. The customhouse roughly served the same functions as today's federal building, except it also housed the city post office. In 1889, an addition was completed on the Summers Street side of what became known as Post Office Square. The building was torn down in 1910 to make way for a new federal building.

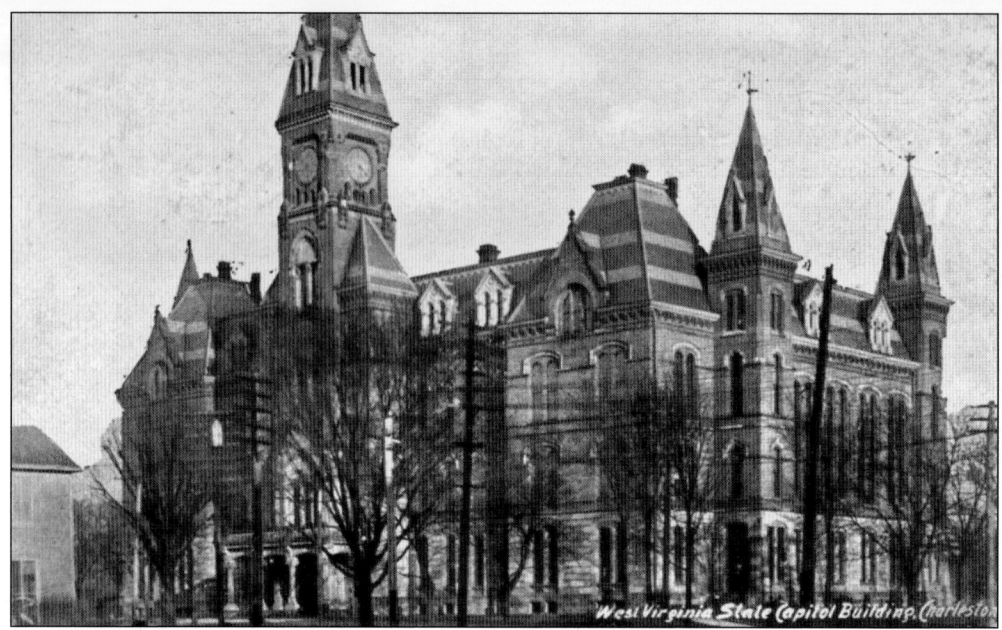

**THE STATE CAPITOL.** This building at the corner of Capitol and Lee Streets was West Virginia's fourth capitol building and Charleston's second. After a construction delay in 1884, Charleston's Henry Ruffner and James Grady completed the approximate $350,000 structure. The capitol was opened in 1885 but not dedicated officially until January 1887. The building on the bottom left of the photograph was the first permanent YMCA building.

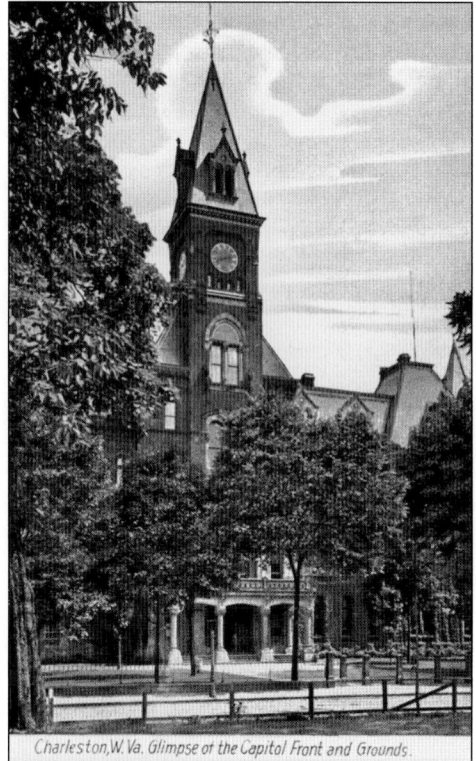

**CLOCK TOWER.** This view from the current Davis Square shows the front entrance of the capitol. The clock tower was one of the building's most distinctive architectural features. In 1921, the clock tumbled to the ground 30 minutes after the capitol burst into flames. All that remained were some chimes (now in the state museum collection) and the bell, which was melted for scrap metal during World War II.

*Three*

# A MODERN CITY
## *1886–1919*

Charleston changed dramatically after it became the permanent capital. Effective communication and transportation outlets were the keys to economic success. The city council paved streets, built a public water system, and installed electric streetlights. Local businessmen started the city's second telephone exchange—an earlier attempt had failed due to lack of interest. In the 1890s, Charleston introduced mule-drawn streetcars, which were later powered by electricity.

Another change was a gradual shift of the business district. The growth of stores crept from the corner of Capitol and Kanawha Streets north toward the capitol. By the early 20th century, Capitol Street had supplanted Kanawha Street as the city's commercial center.

The city also expanded its boundaries to the east, south, and west. The first major suburb was Elk City, which comprised all the West Side east of Delaware Avenue. Prior to the Civil War, the region had been almost entirely farmland. By the time Elk City was annexed by Charleston in 1895, it had an electric streetcar line, waterworks, six churches, two grade schools, a large furniture factory, veneering mill, sawmill, sash and door factory, and two brick factories.

This is just one example of Charleston's development between 1880 and 1920, when the population exploded from 4,192 to 39,608. With this growth came services to support a modern city: schools, hospitals, and hotels. During this era, Charleston was partially reshaped into the city still recognizable today.

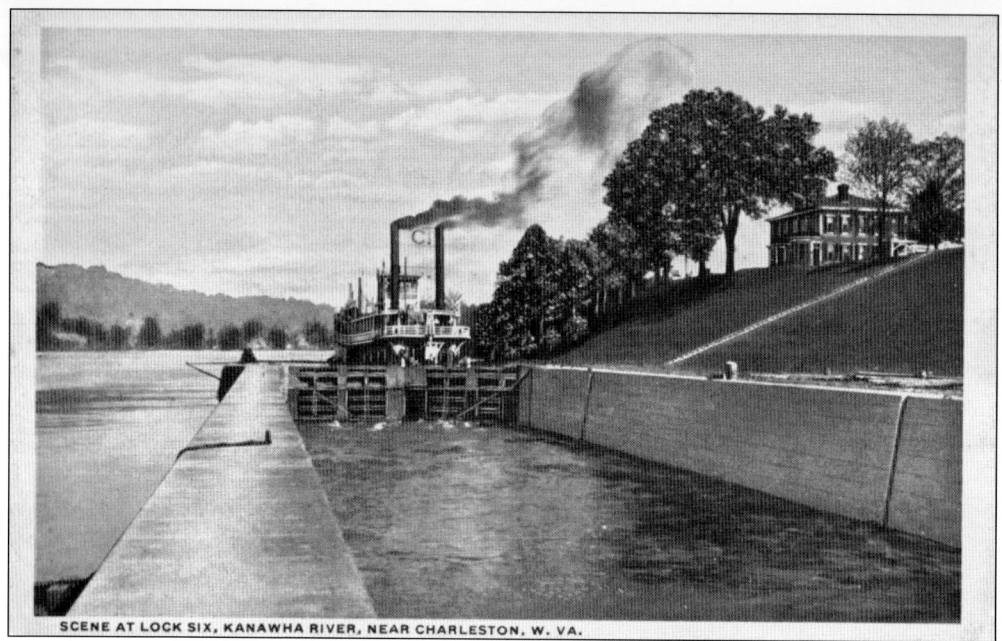

SCENE AT LOCK SIX, KANAWHA RIVER, NEAR CHARLESTON, W. VA.

**LOCK 6.** In 1886, engineers completed this lock and dam spanning the Kanawha River between present North Charleston and South Charleston, six years after finishing Locks 4 (Dickinson) and 5 (Marmet). With the opening of other locks and dams over the next 12 years, the Kanawha River became a major navigable shipping lane. These locks were replaced in the 1930s. Notice the lock master's house on the hillside.

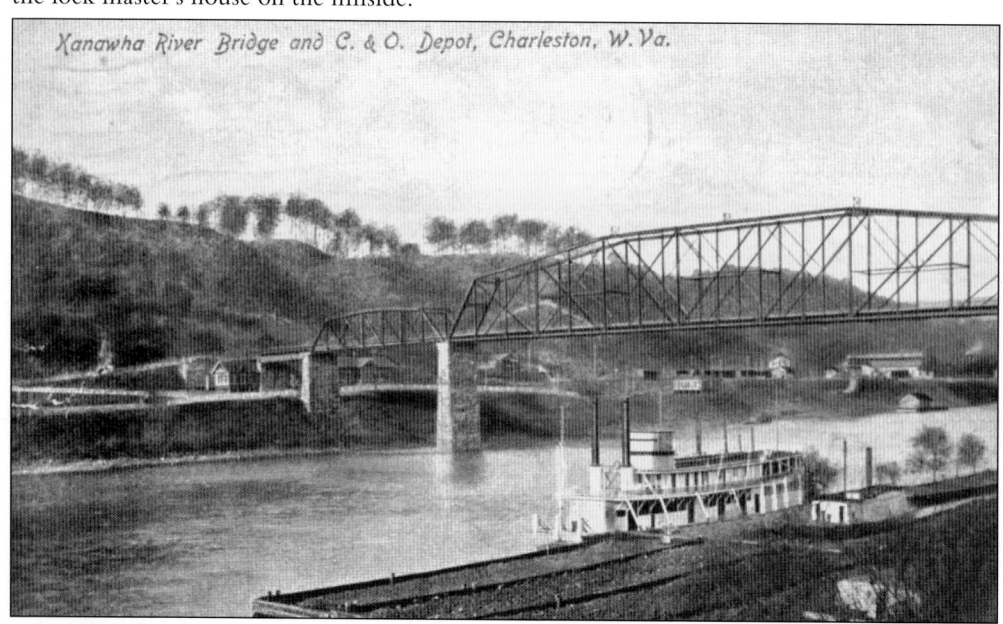

**COAL BARGES.** The completion of Locks 4, 5, and 6 allowed operators to ship coal from eastern Kanawha County mines to Charleston. It also created a six-foot-deep, 14-mile-long slack-water harbor for coal barges between Marmet and North Charleston. As a result, Charleston soon became the main headquarters for the state's coal industry. By 1910, 31 coal companies had set up offices in Charleston; 10 years later, the number had doubled.

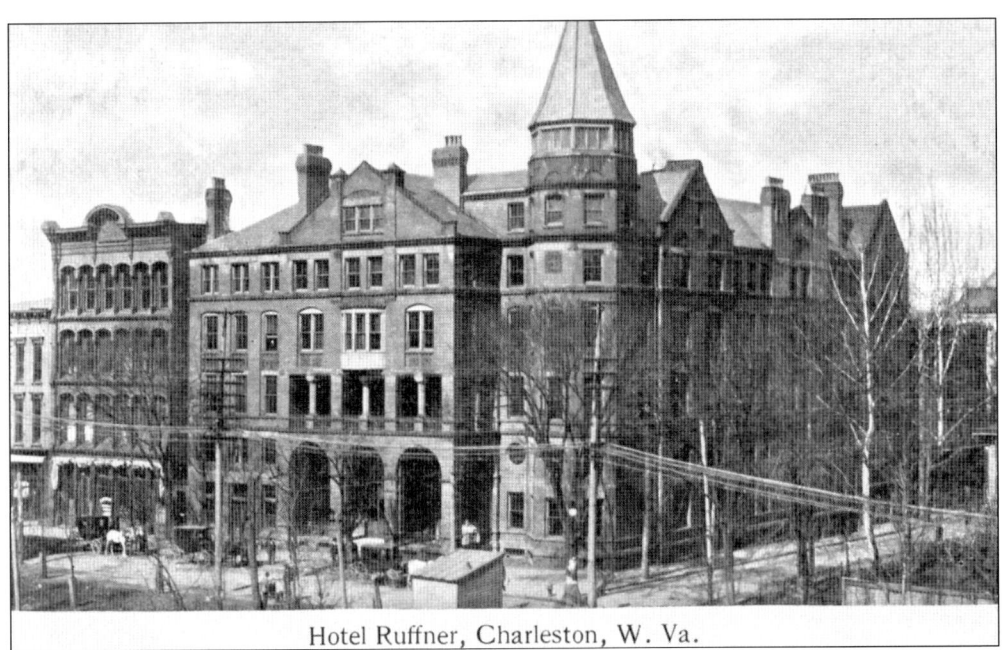

Hotel Ruffner, Charleston, W. Va.

**RUFFNER HOTEL.** John P. Hale believed a luxurious hotel was essential to Charleston's development. In 1872, he built the magnificent Hale House on the northwest corner of Kanawha Street (now Boulevard) and Hale Street. After it was destroyed by fire, Andrew and Meredith Ruffner constructed the Ruffner Hotel on the same site in 1886. The Ruffner instantly became Charleston's premier hotel but was bypassed by more modern facilities in the mid-20th century. It was demolished in 1970.

**ST. JOHN'S EPISCOPAL CHURCH.** The first St. John's Episcopal Church was built at Virginia and McFarland Streets in 1839. During the Civil War, it was used as a Union army storehouse. In 1888, the congregation dedicated the building in this postcard; however, it was not completed for another 13 years. The church helped form other area Episcopal churches, including St. Luke's, St. James', St. Matthew's, All Saints' Church, and the Church of the Good Shepherd.

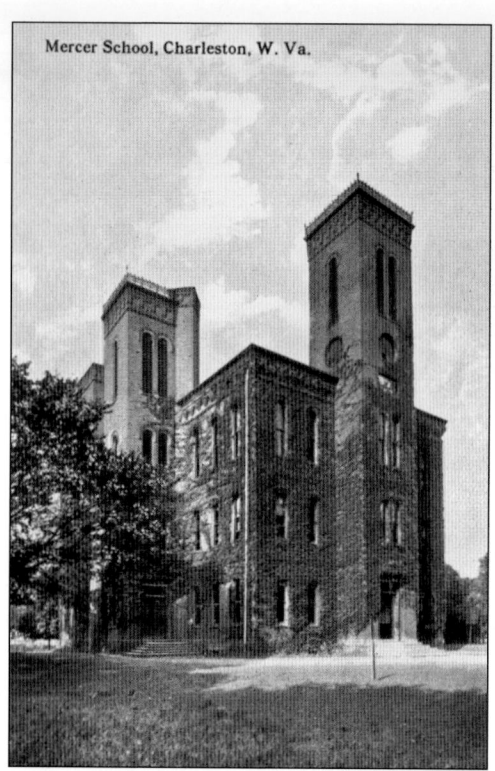

**MERCER SCHOOL.** In 1889, the 16-room Mercer School opened on Washington Street as a combination grade school and temporary home for Charleston High. At the time, Mercer was the city's most modern schoolhouse, featuring a 700-seat auditorium. The building was torn down to make way for the new Charleston High School, built in 1926.

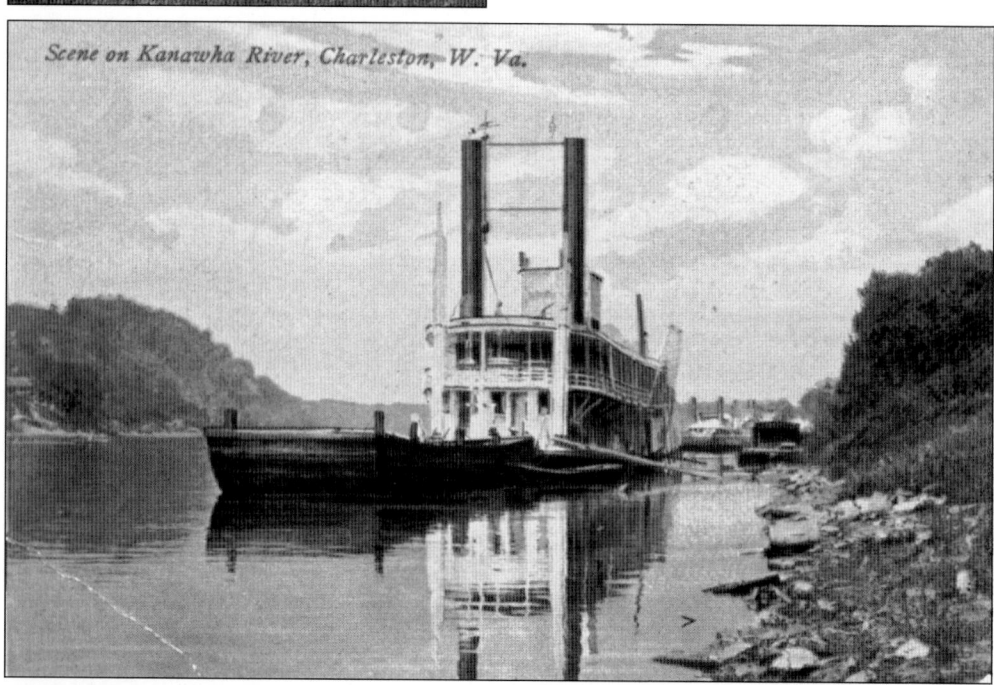

**THE LEVEE.** By the 1890s, Charleston businesses received most of their merchandise and supplies via the railroad. Prior to the railroads, the Charleston levee was continuously packed with ships dropping off goods. Even after railroads transformed the business world, the levee continued to be a focal point of shipping activity until roads were improved in the 1920s.

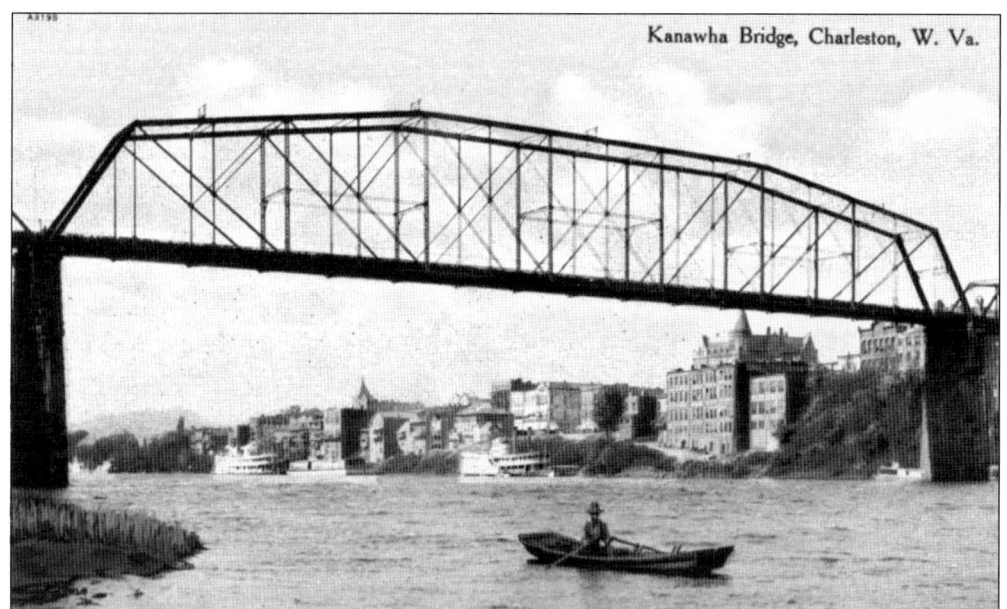

SOUTH SIDE BRIDGE. In the late 19th century, the C&O Railway was the main means of transportation to and from Charleston; however, the Kanawha River separated the business district from the railroad. For many years, ferries operated at different points along the river, but they were slow and undependable. In 1890, the Charleston Toll Bridge Company, composed of investors from Pittsburgh and Charleston, began construction of the South Side Bridge.

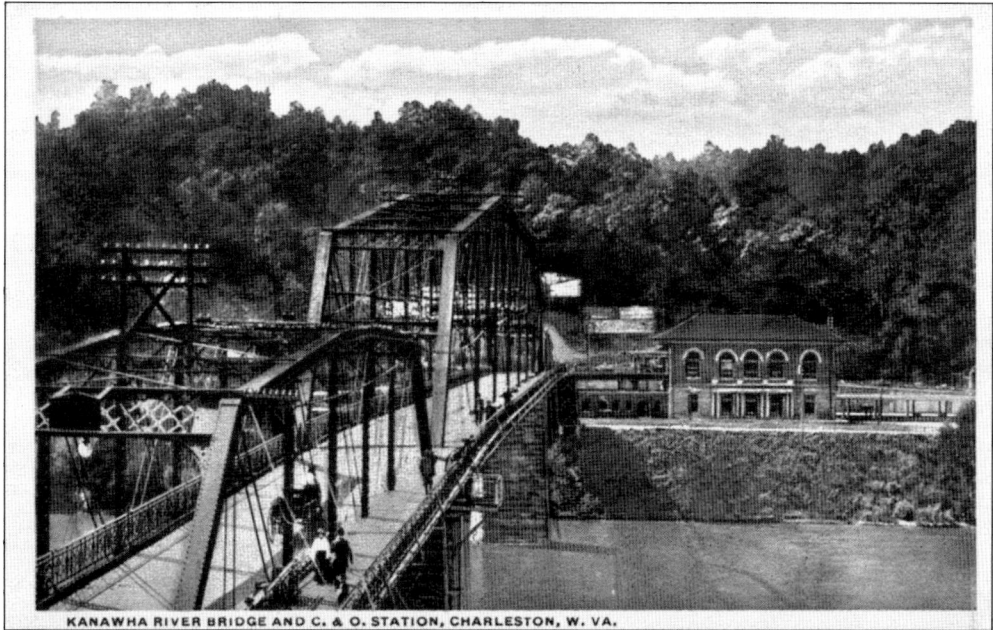

SOUTH SIDE BRIDGE. The South Side Bridge was dedicated on April 1, 1891, connecting downtown Charleston directly with the C&O station. It was the first bridge ever to span the Kanawha River at Charleston. The bridge was a boost for stores and also sparked the rapid development of South Hills. It was torn down in 1936 to make way for the current South Side Bridge. In this postcard, notice the billboards at the end of the bridge.

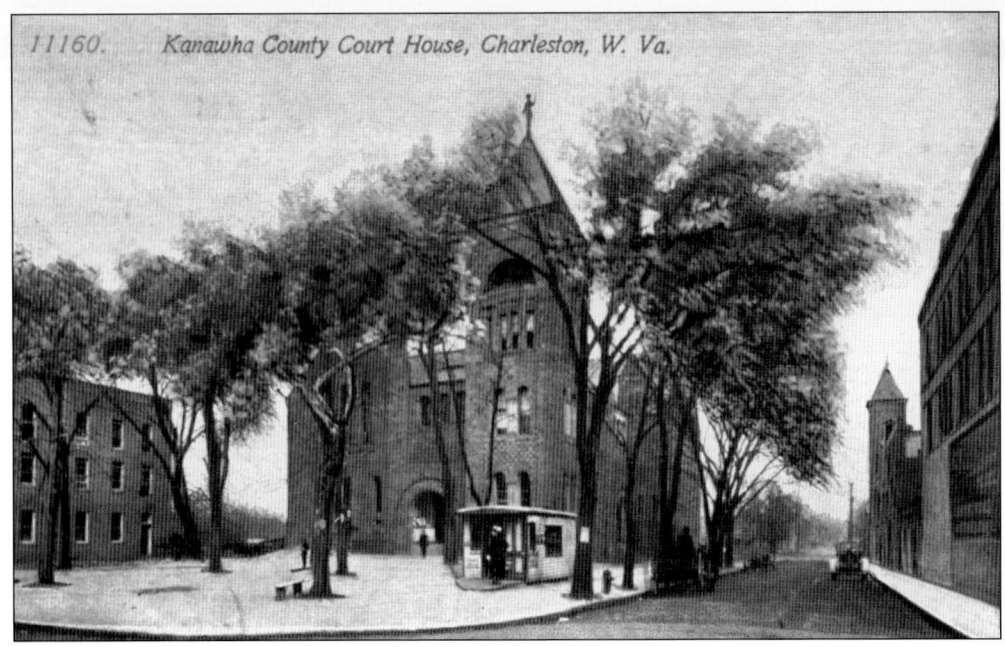

**KANAWHA COUNTY COURTHOUSE.** In the 1790s, the county built its first courthouse on this lot bounded by Court, Kanawha, and Virginia Streets. A brick courthouse stood on the same lot from 1817 to 1888. The first part of the building shown in the postcard was completed in 1892, with a new section added along Kanawha Street in 1917. The turret in the distance on the right belonged to the old city hall.

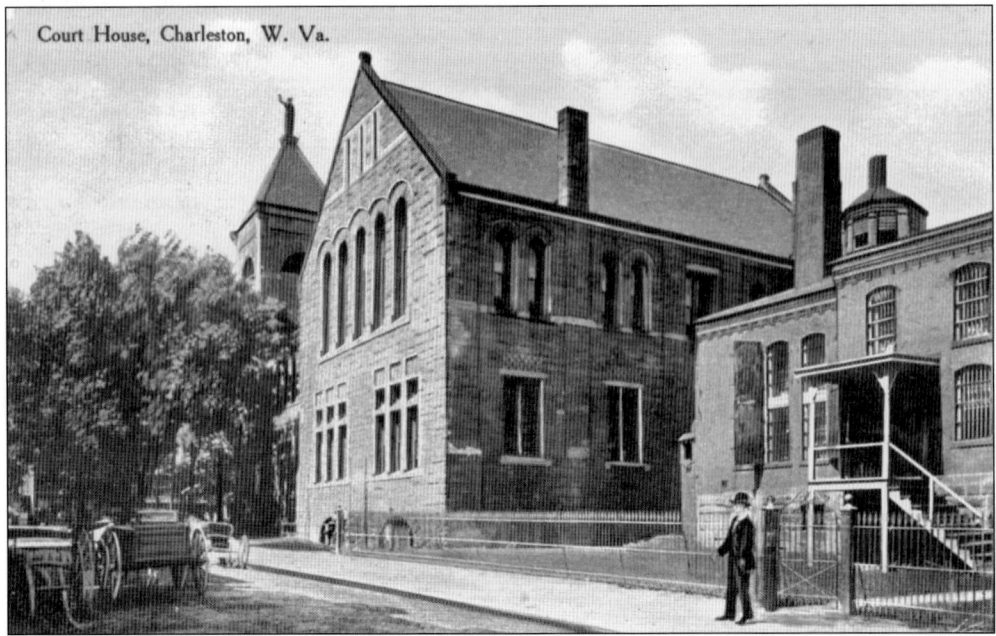

**KANAWHA COUNTY JAIL.** The Pauley Jail Company completed the county jail building (on the right) in 1888. It was torn down to allow for a large expansion of the courthouse along Virginia Street in 1924. The addition included a new jail and tripled the courthouse's original size. On the left, notice the old fire-hose carriage in front of the fire department.

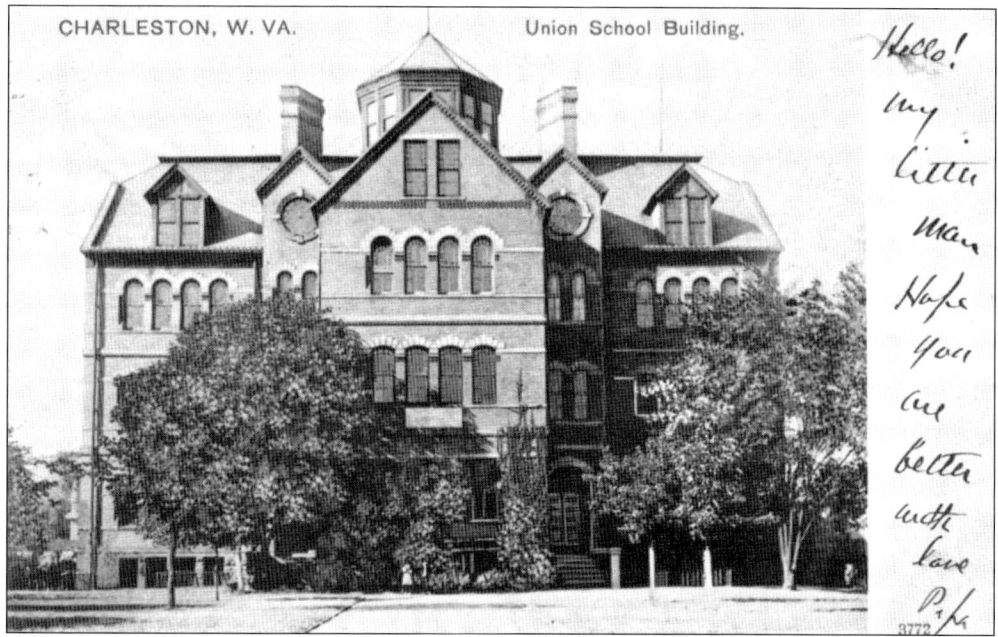

UNION SCHOOL. This grade school was opened on the south side of State Street (current Lee Street) between Court and Laidley Streets in 1892. It was built on the site of the city's first permanent public school, which also had been the first temporary home for Charleston High. Union School was torn down in 1932 and replaced by Fruth School.

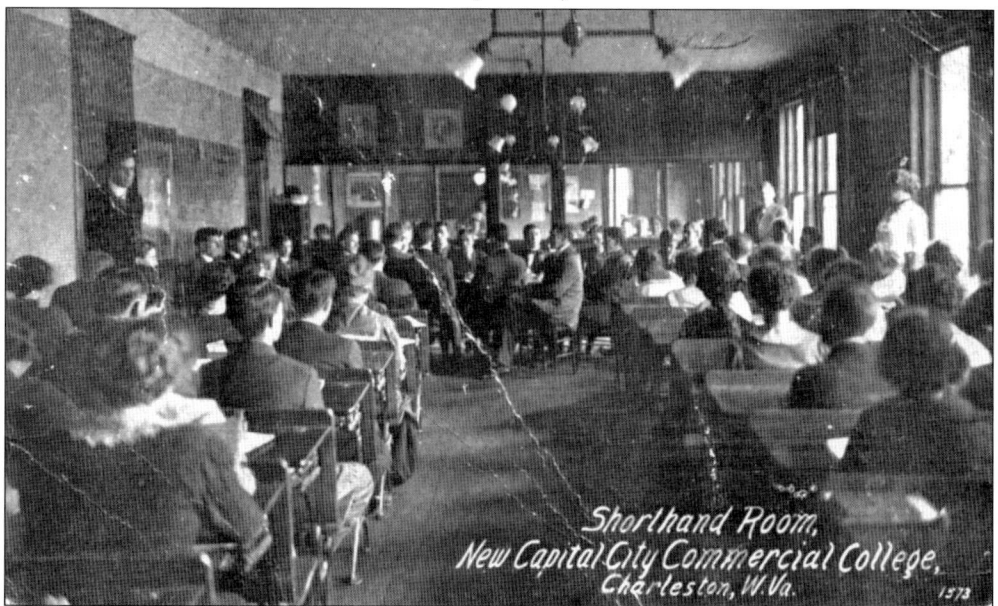

CAPITAL CITY COMMERCIAL COLLEGE. In 1892, W. B. Elliott founded the Capital City Commercial College on two floors of the old Coyle and Richardson building. It later moved to the Odd Fellows Building, where the classroom in this postcard was located. The school offered courses in everything from shorthand to banking. The success of Capital City inspired E. C. Stotts and A. H. Dangerfield to form a better-remembered school, Charleston Business College, in 1919.

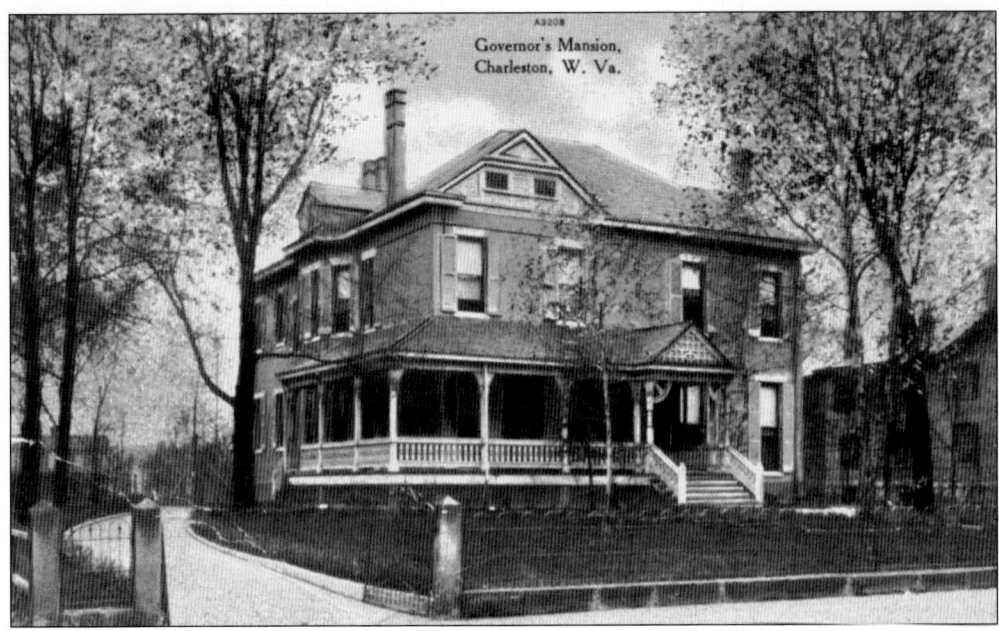

**THE FIRST GOVERNOR'S MANSION.** Clothing merchant Gustave Jelenko built this house on Capitol Street opposite the state capitol about 1887. He sold it to the state in 1893 as the first governor's mansion. Governors previously had been responsible for their own accommodations. Eight governors lived here before the current mansion was completed in 1925. This house was torn down to allow for the extension of Washington Street from Capitol to Summers Streets.

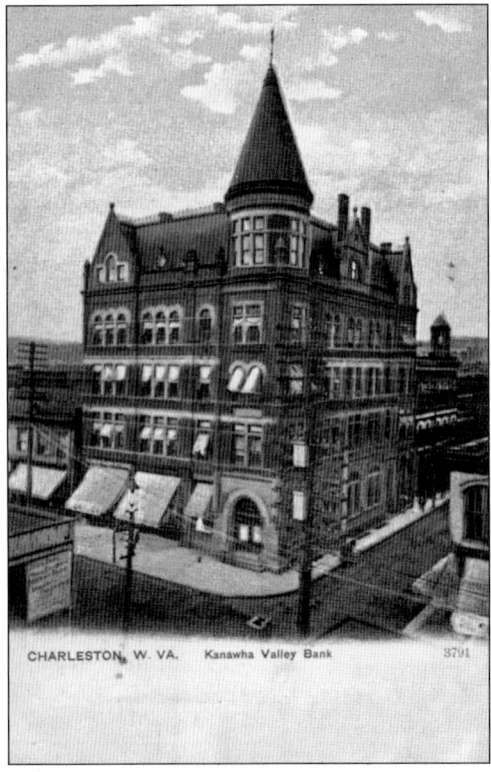

**KANAWHA VALLEY BANK.** For nearly 100 years, the northwest corner of Kanawha and Capitol Streets was occupied by a bank—first the Bank of Virginia then the Kanawha Valley Bank, founded in 1867. The Kanawha Valley Bank built this structure in 1894 and renovated it about 1904, eliminating the distinctive turret. In 1929, the bank relocated to a new high-rise. This building continued to be used for stores and offices until being demolished in the 1960s.

**CHURCH OF THE SACRED HEART.**
Charleston did not have a permanent Catholic church building until Fr. Joseph Stenger arrived in 1866. Stenger renovated an old home on Broad Street (now Leon Sullivan Way) as a chapel, replacing it three years later with a frame building. On Christmas Day 1897, Stenger dedicated the building in this postcard as the Church of the Sacred Heart, which has been expanded and remains in use as the Sacred Heart Co-Cathedral.

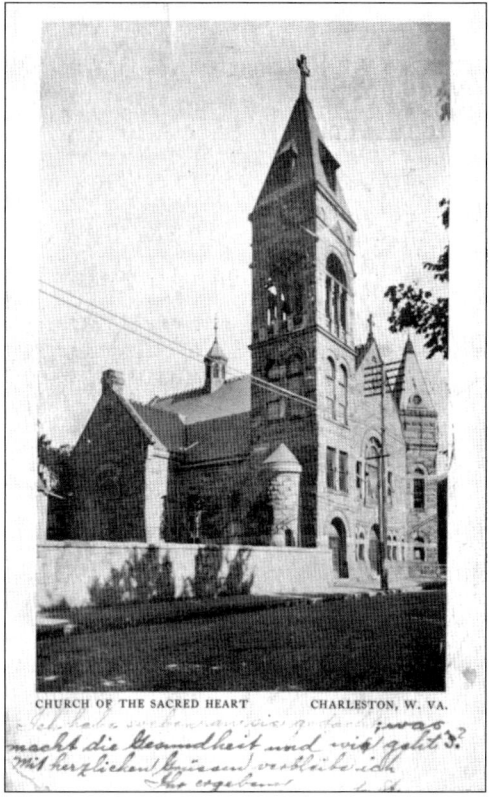

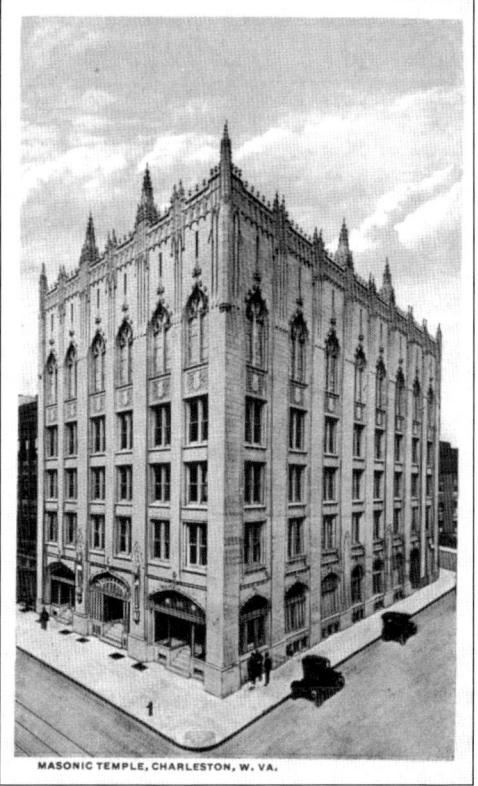

**MASONIC TEMPLE.** The Masonic Temple was built at the corner of Virginia and Hale Streets in 1897. While the Freemasons occupied the upper stories, the first floor was rented out as a storefront. This postcard was issued in 1916 after a renovation to repair fire damage. After the 1921 capitol fire, the state tax commissioner, workmen's compensation bureau, and public health council used the Masonic Temple temporarily for office space.

29

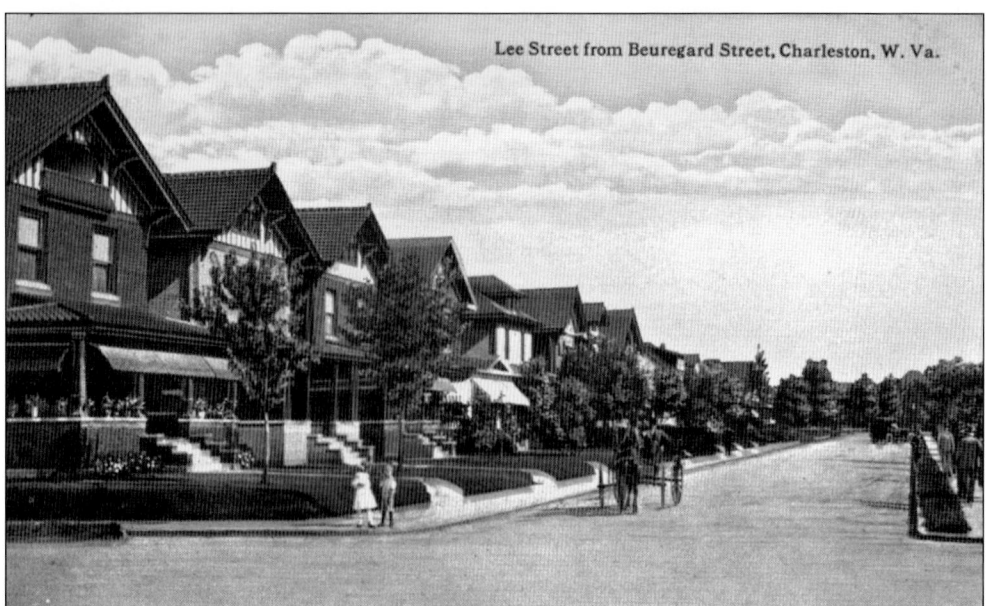

**LEE AND BEAUREGARD STREETS.** From 1871 to 1895, Charleston's boundaries stretched from the Elk River to Bradford Street. Due to the spreading population, the city expanded its limits westward to Delaware Avenue and eastward to the approximate site of the present capitol. Prior to this expansion, the area in the postcard had been outside the city limits and was the site of a combination horse track and baseball diamond.

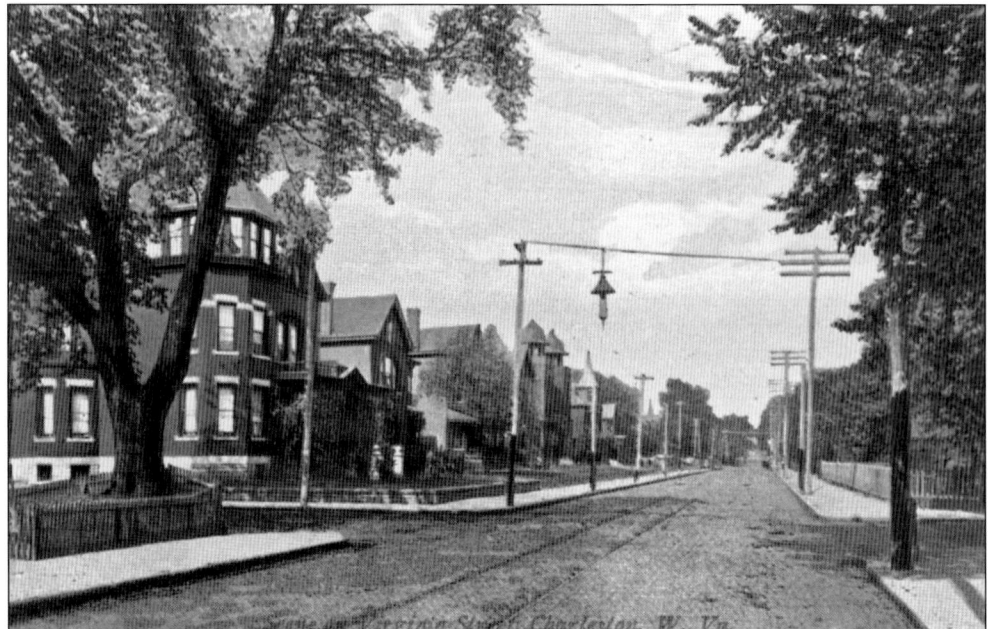

**VIRGINIA STREET AND RUFFNER AVENUE.** Prior to the 1880s, the east end of Virginia Street terminated at Morris Street. The extension of Virginia, Quarrier, and Lee Streets triggered a housing boom that produced the city's most lavish district at the time, the East End. In the distance on the left was B'Nai Israel, known as the Virginia Street Temple, completed in 1894. Notice the early streetlight hanging above the intersection.

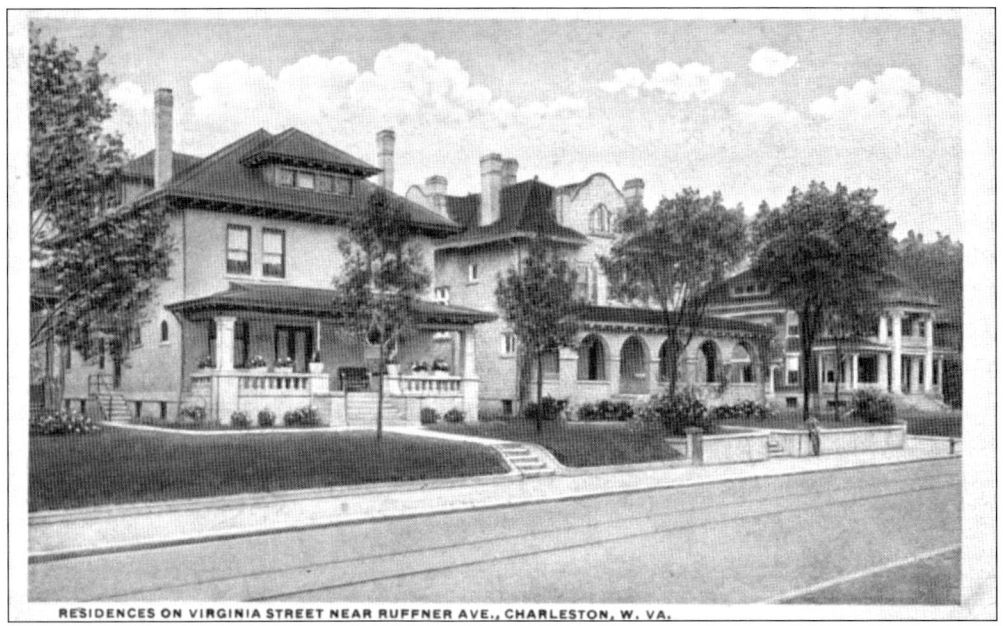

RESIDENCES ON VIRGINIA STREET NEAR RUFFNER AVE., CHARLESTON, W. VA.

**EAST END HISTORIC DISTRICT.** The people who moved to the East End in the late 19th and early 20th centuries had eclectic tastes. The potpourri of architectural styles juxtaposed Spanish Colonial, Queen Anne, Greek Revival, Prairie School, and American foursquare houses. Most of these old homes still exist and are now listed in the National Register of Historic Places as part of the East End Historic District.

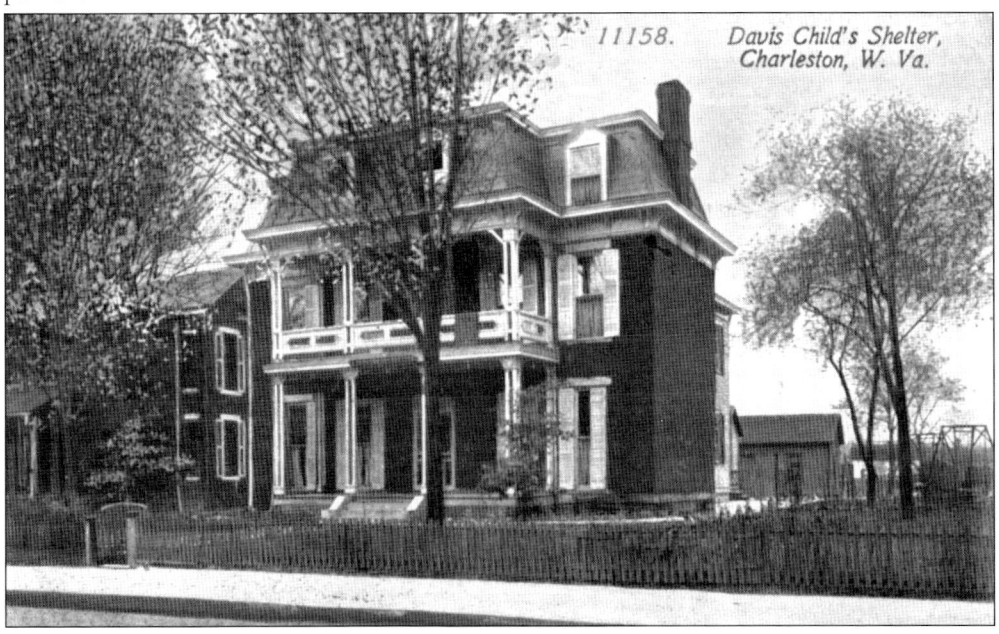

**DAVIS CHILD SHELTER.** In 1896, local ministers formed the Children's Home Society of West Virginia to place needy children in foster homes. Overwhelmed by the number of homeless children, the society established the Davis Child Shelter at 1118 Washington Street in 1900. The shelter, named for philanthropist Henry G. Davis, closed in 1961. Today the Children's Home Society is the largest child welfare organization in the state.

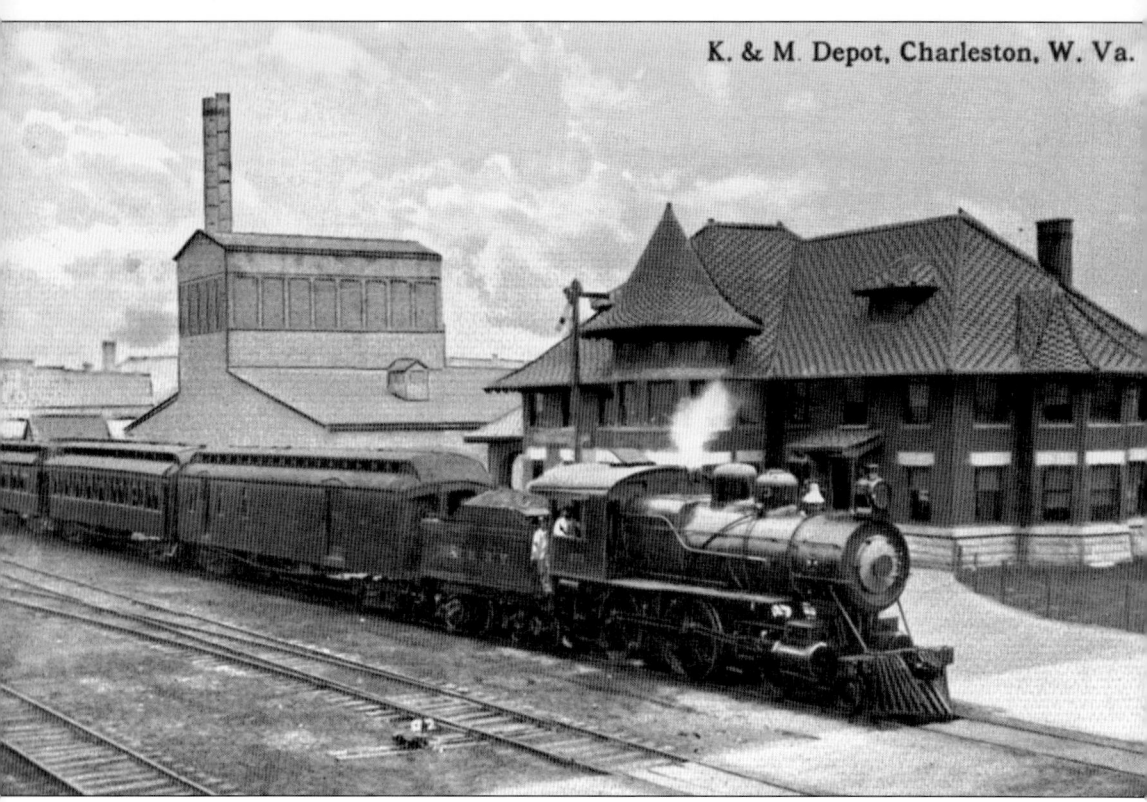

K&M DEPOT. Charleston added its second major railroad when the Ohio Central Railroad was completed from Toledo to Charleston in 1883. Ten years later, the Kanawha and Michigan (K&M) Railroad, which had taken over the line, extended the rails from Charleston to Gauley Bridge. An important industrial route, the K&M connected the southern West Virginia coalfields with the Great Lakes. Beginning in 1900, the K&M built a line of warehouses on the north end of downtown Charleston; it completed this adjoining depot in 1903. The New York Central (NYC) acquired the K&M's lines, depot, and warehouses in 1914. The NYC built branch lines into Clay and Nicholas Counties before being merged into Conrail in 1968; today Norfolk Southern operates the old K&M/NYC lines. The depot was demolished in 1975 as part of the interstate construction. The only remaining structure, a freight warehouse, was renovated into the Capitol Market in 1997.

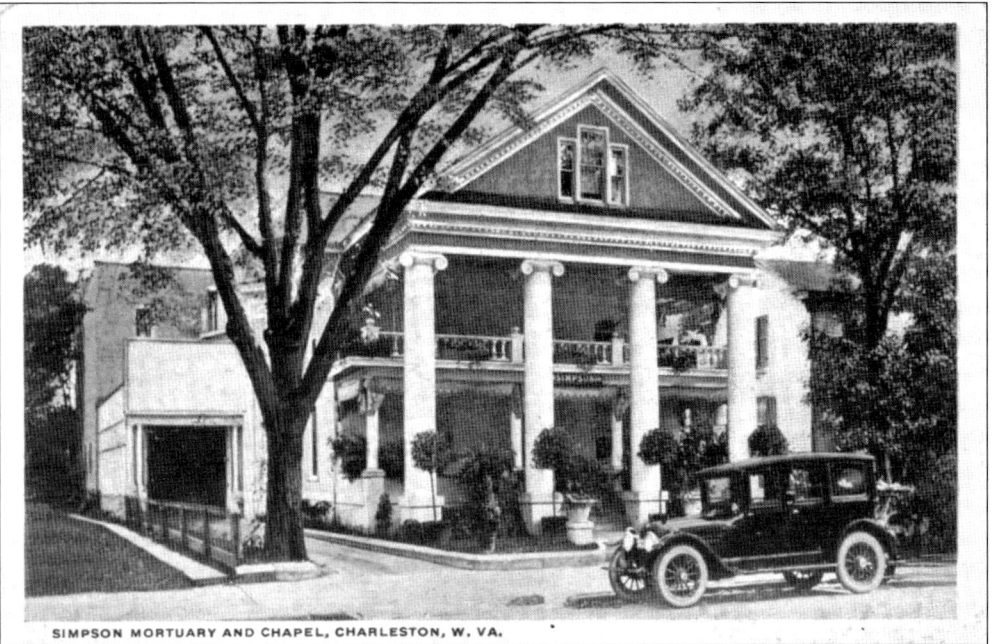

SIMPSON FUNERAL HOME. In 1900, P. A. Simpson operated a livery stable at the corner of Virginia and McFarland Streets. On the back lot, near the present South Side Bridge, he and Robert Steele started an embalming and undertaking business. Several years later, Simpson established this mortuary and chapel at 210 Broad Street (now Leon Sullivan Way). Today this building is operated as the Broadway nightclub.

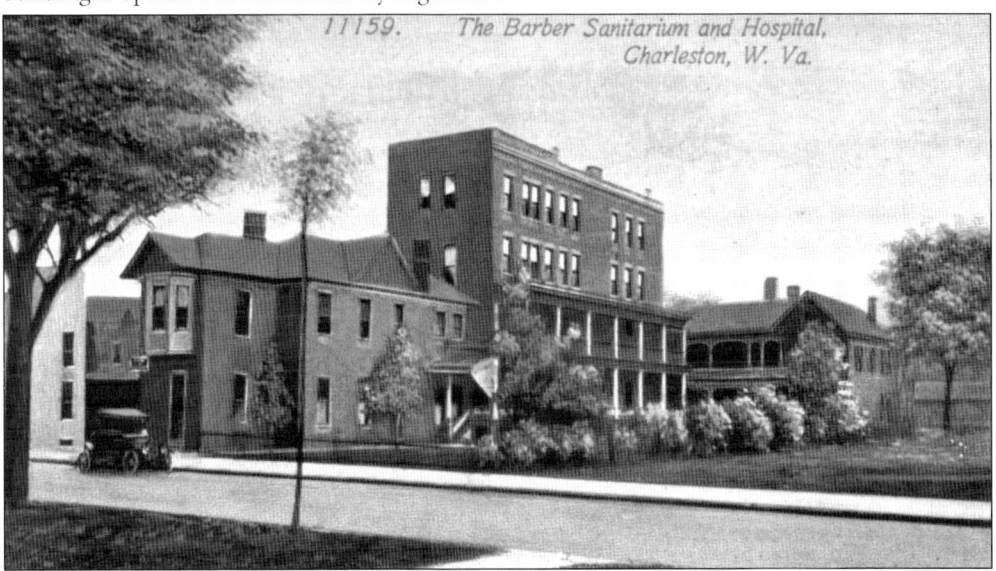

KANAWHA VALLEY HOSPITAL. In 1903, Dr. Timothy Barber opened a sanatorium at present 1020 Virginia Street for the alternative treatment of diseases. After Barber's death in 1910, Hugh Nicholson took over the practice and renamed it the Kanawha Valley Hospital. In 1982, the hospital relocated to Pennsylvania Avenue (now Charleston Area Medical Center's Women's and Children's Hospital). Today the site of Barber's sanatorium is a parking lot on the north side of Virginia Street between McFarland and Dunbar Streets.

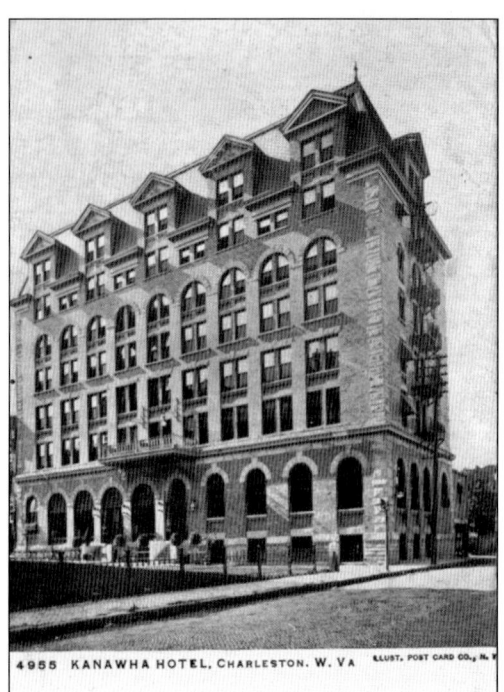

**KANAWHA HOTEL, 1903.** This postcard shows how the Kanawha Hotel looked when it opened in 1903. Designed by Charleston architects Charles Rabenstein and H. Rus Warne, the hotel extended from Summers Street to the Arcade, just south of the customhouse. The success of the Kanawha prompted its owners to buy the corner lot at Summers and Virginia Streets in 1905 and enlarge the hotel.

**KANAWHA HOTEL, 1907.** In 1907, the Kanawha Hotel was renovated completely and expanded to Virginia Street. The hotel hosted many dignitaries but is best remembered as John Kennedy's campaign headquarters during the 1960 Democratic presidential primary. The hotel closed in 1965, and the building became the Charleston Job Corps center. The Kanawha Hotel was demolished in 2003.

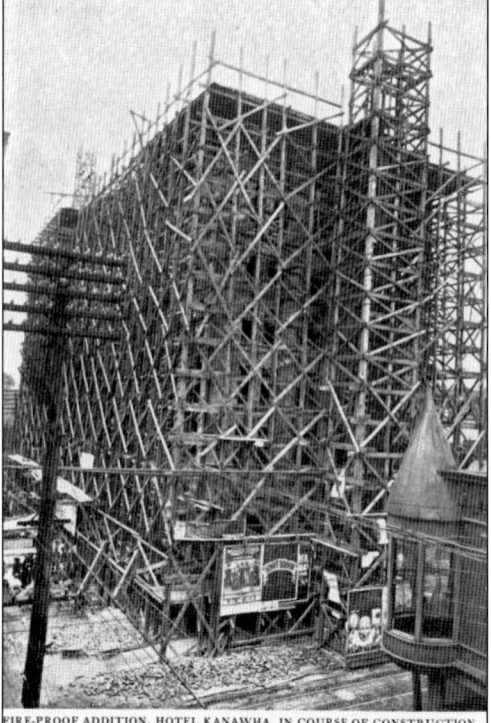

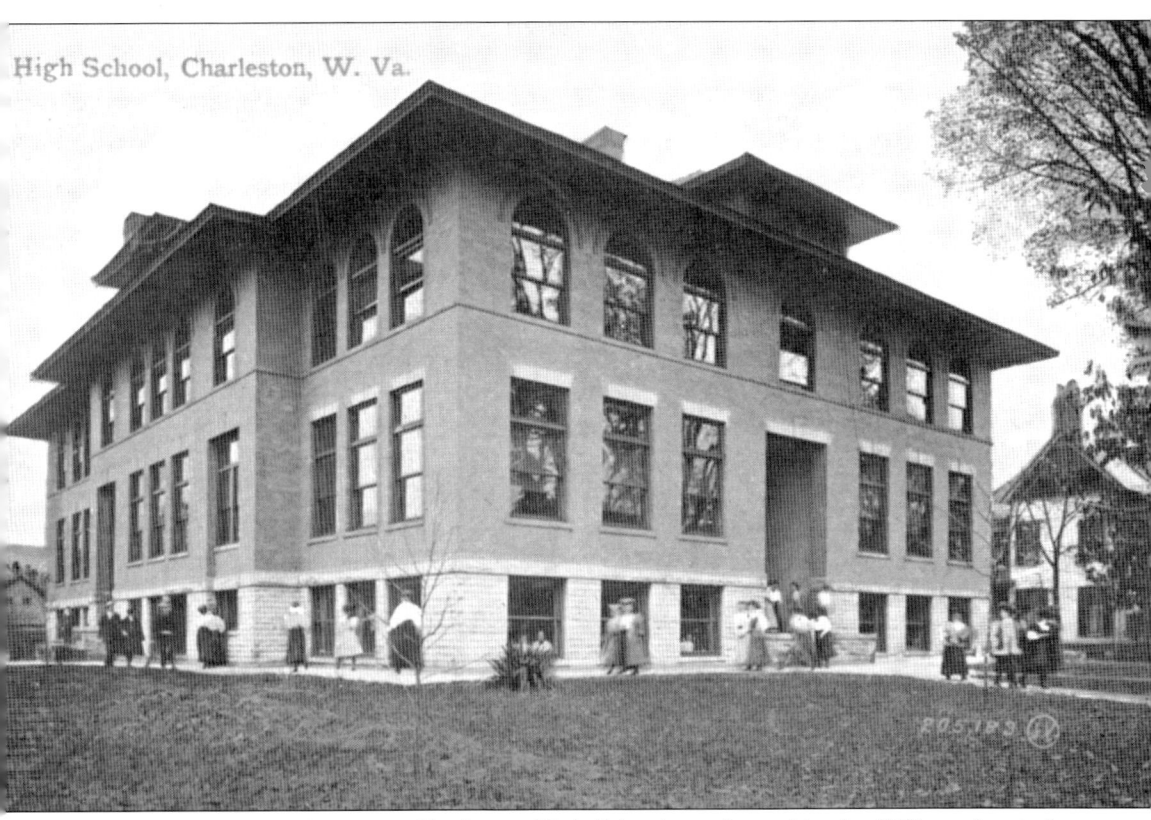

**CHARLESTON HIGH SCHOOL.** Charleston High School was formed in the 1870s as the city's first high school. For nearly 30 years, Charleston High borrowed space in the old Union School and Mercer School. From 1903 to 1915, this 15-room building, located on Quarrier Street between Brooks and Broad Streets, was Charleston High's first permanent home. The school moved to a newly constructed building at the corner of Morris and Quarrier Streets in 1915 and to its final location on Washington Street near Brooks Street in 1926. Charleston High closed in 1989, merging with Stonewall Jackson to form Capital High School. After Charleston High relocated in 1915, the facility shown here became Central Junior High. It later served as Mercer Grade School and as a board of education facility before being torn down in 1970. The site of this school is now a parking lot just west of the YWCA building.

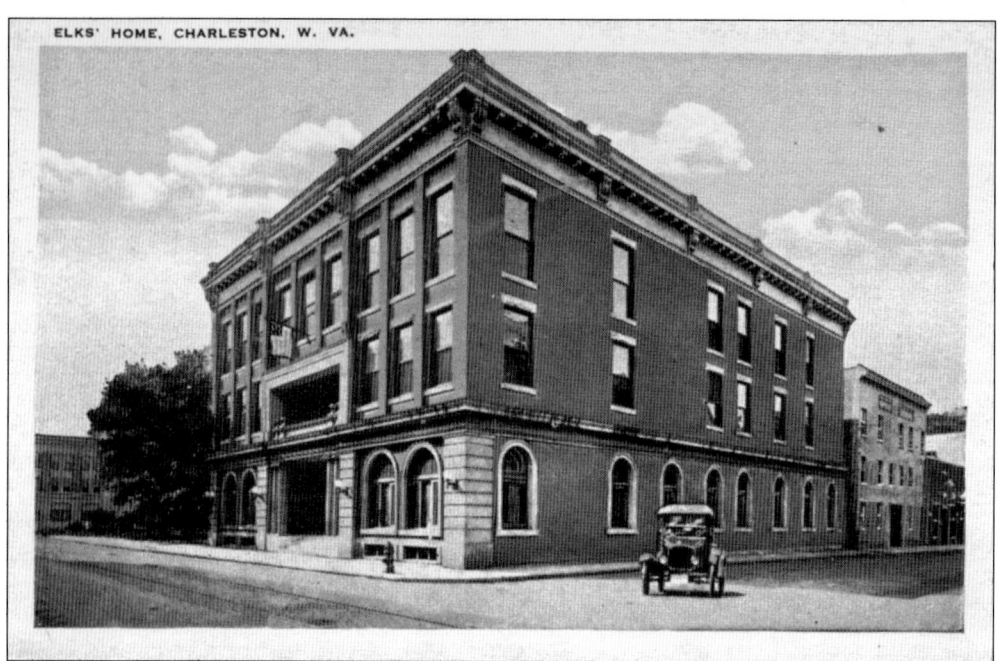

**ELKS CLUB.** In 1904, the Benevolent and Protective Order of Elks acquired this building on the southeast corner of Quarrier and McFarland Streets. In 1921, after fire destroyed the capitol, the third floor of the Elks Club served as the attorney general's temporary office.

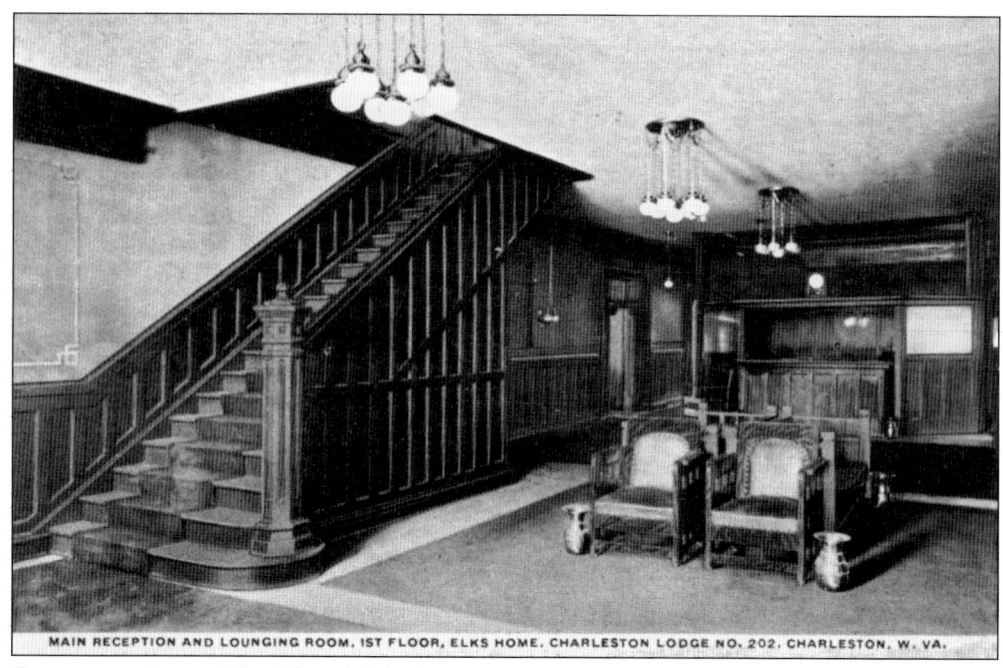

**GERMANIA CLUB.** The Elks Club building was constructed in 1877 by the Germania Club, which had been founded the previous year as a Jewish social club. In 1898, the building was also rented as winter quarters by the Glenwood Athletic Club, which eventually became Edgewood Country Club.

**CHARLESTON GENERAL HOSPITAL, 1904.** Charleston's first hospital opened on Capitol Hill at the end of Capitol Street in 1896. The city initially operated the hospital but contracted the work to Dr. Frederick Thomas in 1898. When Thomas's contract expired in 1904, a group of local physicians reorganized the hospital as part of Charleston General.

**CHARLESTON GENERAL HOSPITAL, 1924.** In 1924, all patients and equipment from the Capitol Hill hospital were transferred to a new 120-bed facility at the corner of Elmwood Avenue and Brooks Street. Charleston General merged with Charleston Memorial in 1972 to become the General Division of the Charleston Area Medical Center. The original building on Elmwood Avenue and Brooks Street still stands but is overshadowed by a massive hospital complex.

**SUSPENSION BRIDGE COLLAPSE.** Tragedy struck on the morning of December 15, 1904, when this wire suspension bridge at Lovell (present Washington) Street plunged into the icy Elk River. Two large cables broke from their moorings, overturning the deck. A number of children were on the bridge walking to the Union School. Two of them, Mamie Higgenbotham and Ray Humphreys, were killed.

**WASHINGTON STREET BRIDGE.** The Washington Street Bridge was erected on the site of the former suspension bridge. The city eventually replaced it in the 1970s. The first bridge on the site had been completed in 1852 as part of the Charleston and Point Pleasant Road. During the Civil War, Union troops had cut the cables to deter pursuing Confederates. The suspension bridge was rebuilt after the war and used until its collapse in 1904.

Baptist Temple, Charleston, W. Va.

**BAPTIST TEMPLE, 1904.** In October 1869, local residents met at the Kanawha County Courthouse and formed the Charleston Baptist Church. After occupying two frame structures in the late 19th century, the Baptist Temple congregation erected this stone building designed by Harrison Albright on the northeast corner of Capitol and Washington Streets in 1904. After fire destroyed the capitol in 1921, the Baptist Temple provided temporary space for the state house of delegates.

521—The Baptist Temple, Charleston, W. Va.

**BAPTIST TEMPLE, 1925.** By 1925, the 1,700-member Baptist Temple congregation needed a larger facility. They built this church on the northwest corner of Quarrier and Morris Streets and added an activities building in the 1950s. It continues to be a place of worship. The 1904 cornerstone from the old Baptist Temple is located in front of the building.

CAPITOL ANNEX. In less than 20 years, state government had outgrown the capitol's confines. Charleston architect Harrison Albright designed an annex that was built on the southeast corner of Lee and Hale Streets. In 1905, the state museum, archives, and other agencies moved into the new building. After these offices moved to the new capitol, the annex was home to the public library from 1926 to 1966 and Morris Harvey College from 1935 to 1947.

CAPITOL STREET, FIRST BLOCK, 1905. This postcard captures the first block of Capitol Street in its prime. Looking south from the corner of Virginia Street, the brick building on the right was the Lawrence Block, built in 1881. Several years after this postcard was published, Charleston Cut Flower, which had started on Quarrier Street in 1903, moved into 19 Capitol Street, to the left of the Lawrence Block. All these buildings were demolished in the early 1960s.

CHARLESTON, W. VA., View of Charleston from C & O. Depot    3790

**DIAMOND ICE AND COAL.** This view of the Charleston skyline shows a distinctive group of structures that appear in photographs of the riverbank prior to the late 1930s, when the buildings were torn down to widen Kanawha Street into a boulevard. At the time of this 1905 postcard, the buildings were occupied by several businesses, including the Charleston *News-Mail*, which would become the Charleston *Daily Mail* newspaper, and the Diamond Ice and Coal Company. William Slack, Sidney and Susan Staunton, Edward Knight, and Isaac Smith formed Diamond Ice in 1883. In 1890, the company added home delivery of coal to its ice business. Diamond Ice and Coal had a large storage facility along the Elk River at the K&M tracks and a coal yard at the corner of Capitol and Dryden Streets. Diamond Ice and Coal survived competition from refrigerators and home heating systems and remained in business until the 1960s.

**CAPITOL STREET, 100 BLOCK, 1905.** This photograph is from the perspective of the current library looking south. On the left, from front to back, are the Washburn Hotel, S. Spencer Moore Company, S. A. Moses's saloon, and the Sterrett Brothers' grocery store. The Sterrett building was later J. C. Penney's first Charleston store. On the right was the Charleston National Bank, one year before it moved into its new building.

**CAPITOL STREET, 100 BLOCK, 1905.** This postcard is from Capitol and Virginia Streets looking north. The building on the right is the Kanawha National Bank. Proceeding down the street, the next businesses are Richardson Brothers' stationery shop (with Kanawha Distilling upstairs), Goldbarth and Strauss's clothing store, E. L. Boggs's pharmacy, and Charles Gates's grocery store. The Gates Building was occupied by Silver Brand Clothes in the 1970s.

KANAWHA STREET, 1905. Few of the views in this book have changed more than this one. For this same perspective today, a photograph would have to be taken from the middle of Kanawha Boulevard just east of Capitol Street looking west. In the late 19th century, this was Charleston's prime business district; by 1905, however, it was quickly being overshadowed by Capitol Street. With the exception of the Kanawha Valley Bank building on the right, the remaining structures were built after a devastating fire on January 19, 1874. The block was a prime location that experienced much less business turnover than other areas. By 1905, Richard Satterthwait's jewelry store, Noyes Burlew's and Lovell Gates's hardware stores, I. E. Nichols's confectionery, and Ben Gallenberg's saloon all had occupied the street for more than 20 years. The two-story building to the left of the Kanawha Valley Bank served as one of the first May Shoe Store locations. Other longtime businesses in this block included Abraham Polan's and Abraham Boiarsky's jewelry and pawnshops.

**JACOB FRIEDMAN.** In 1905, the staff of Jacob Friedman's clothing store posed in front of 17 Capitol Street. The Austrian-born Friedman started his first business in the 100 block of Capitol Street in the 1890s. Many Jewish immigrants, like Friedman, began their careers as pack peddlers—traveling salesmen who sold clothing and goods in the southern West Virginia coalfields. Many earned enough to open retail stores in Charleston and other towns centrally located to the coalfields. By the early 1920s, 17 Capitol Street was the site of the Charleston Department Store and Brooks Music Studio, featuring instructor George Crumb Sr., the father of Pulitzer Prize–winning composer George Crumb. Brooks Music Studio was succeeded at 17 Capitol Street by Galperin Music.

"Sunrise," Residence of Ex-Gov. Wm. A. MacCorkle, Charleston, W. Va.

**SUNRISE.** William MacCorkle was an attorney, industrialist, and the state's governor from 1893 to 1897. He also was one of the first to anticipate and promote the growth potential of Charleston's South Hills section. In 1905, he constructed Sunrise overlooking downtown Charleston. MacCorkle filled his mansion with treasures from world travels, including stones from the Roman Coliseum and the Great Wall of China. MacCorkle resided at Sunrise from 1905 until his death in 1930. In 1961, Sunrise was opened as a public museum; Torquilstone, the nearby home of MacCorkle's son, was converted into an art gallery in 1967. Sunrise Museums closed in 2004 and reopened in the new Clay Center for the Arts and Sciences as the Avampato Discovery Museum. Sunrise now is occupied by the Farmer, Cline, and Campbell law firm.

C. & O. STATION, CHARLESTON, W. VA.

**C&O STATION.** The C&O station officially opened on December 23, 1905. It replaced an earlier wooden structure that had become, in the words of company officials, an "embarrassment." Until roads were improved in the 1920s, most people entered and departed Charleston through this and other train stations. Today the C&O depot is an Amtrak passenger station and the site of Laury's Restaurant. It is listed in the National Register of Historic Places.

Edgewood Road, Charleston, W. Va.

**EDGEWOOD.** About 1906, painter and real-estate developer Steele Hawkins Sr. laid out streets and sidewalks in the West Side hills, making Edgewood the city's first planned community. The Charleston Traction Company established a streetcar line that ran past Edgewood's famous cave to an amusement park. Many prominent Charlestonians built houses in Edgewood, which already had a number of stately homes, including one of the city's oldest, Glenwood, built in 1852.

**EDGEWOOD PARK.** For a few short years, Edgewood Park was one of the city's favorite entertainment venues. Among other attractions, it featured a penny arcade, a merry-go-round, and a skating rink that doubled as a basketball court. The park closed around 1915. The merry-go-round, according to some accounts, was bought by Huntington's Camden Park, where it still is in use.

**EDGEWOOD COUNTRY CLUB.** In 1898, the Glenwood Athletic Club built a golf course and tennis courts near Park Avenue on the West Side. The club moved to the Edgewood Country Club in 1906 and built a golf course. The building was destroyed by fire in 1935 and rebuilt the following year. In the late 1960s, the club built a new 18-hole course at Sissonville but retained the clubhouse in Edgewood. The city now operates the former nine-hole Edgewood course as Cato.

954 CHARLESTON NATIONAL BANK BLD. CHARLESTON, W. VA.
ILLUST. PO. CARD CO., N. Y.

**CHARLESTON NATIONAL BANK.** Charleston National Bank was established in 1884 at 614 Front Street (now Kanawha Boulevard). It was Charleston's first national bank; all others had started originally as state-chartered institutions. About 1890, the bank moved to a building just south of the current library. In 1906, Charleston National Bank constructed the building in the postcard on the west side of Capitol Street opposite Quarrier Street. The bank rented out the storefront on the right side to the May Shoe Company. By the 1930s, Charleston National Bank had merged with five other institutions to become the state's largest bank. This building served as the bank's home until 1969, when Charleston National Bank moved to a 17-story structure at the corner of Virginia and Summers Streets. The building shown in the postcard was torn down in December 1970 to make way for the city's first McDonald's restaurant.

**RUFFNER BROTHERS FIRE, 1907.** On November 9, 1907, a large crowd gathered along Kanawha Street to watch firemen unsuccessfully battle a blaze at the Ruffner Brothers' Grocery. Today this same view would be from the South Side Bridge ramp looking west down the boulevard with Hale Street on the right. Near the center of the photograph is a horse-drawn steam fire engine, similar to the one now on display at the Charleston Civic Center Coliseum. Notice the people looking out the windows of the Standard Oil offices on the left and the men standing atop the *Daily Mail* building in the distance. Both of these buildings were demolished in the late 1930s as part of the Kanawha Boulevard construction. Andrew and Meredith Ruffner opened their wholesale grocery business in the 1870s. In 1882, they bought the adjoining Hale House from John P. Hale, who had declared bankruptcy. Ironically, in 1885, a boiler explosion in the same warehouse started the fire that destroyed the Hale House. The Ruffners replaced their grocery warehouse at present 814 Kanawha Boulevard with a larger structure, which now has been converted into condominiums.

New Railway Bridge,
Charleston-on-Kanawha, West Virginia.

**CHARLESTON RAILROAD BRIDGE.** The first and only railroad bridge ever to cross the Kanawha River at Charleston was built on the West Side in 1907. The bridge connected the C&O tracks on the south side of the river with the K&M on the north side. The eastern side of the bridge also permitted horse, carriage, streetcar, and pedestrian traffic. The bridge still stands but is no longer in use. In this 1907 concept postcard, notice how the tracks on the opposite side disappear into the hillside. In fact, the drawing fails to show the C&O tracks on the near side or the K&M tracks on the other side. However, the card accurately depicts how sparsely this part of West Charleston was populated. While Elk City, located east of Delaware Avenue, had been an established town dating to the 1870s, this section of the West Side was far less developed until 1907, when it was annexed by Charleston. Within 20 years, a housing boom would change this view dramatically.

**South Charleston.** In 1907, the Kanawha Land Company bought most of what would become South Charleston. At the time, the area was principally farmland. Former-governor William MacCorkle, one of the company's leading investors, convinced the Charleston Traction Company to extend a streetcar line across the new railroad bridge. To attract residents, the land company virtually gave away real estate to companies. The first to take advantage of the offer was Banner Glass, a cooperative composed of Belgian glassworkers. In 1908, Dunkirk Glass relocated from Dunkirk, Indiana, and St. Louis. It built the factory shown in this postcard. The influx of glassworkers led to South Charleston's rapid growth, developing from farmland in 1907 to a chartered city in 1917. The chemical industry eventually overshadowed the glass factories. Libbey-Owens bought Dunkirk Glass in 1928. Five years later, Union Carbide purchased Dunkirk's property and demolished the buildings shown in the postcard.

**KANAWHA SCHOOL.** The rapid growth of the East End required more schools. One of the first was the Kanawha School, built on Elizabeth Street between Quarrier and Lee Streets in 1907. Eight years later, an annex was added across the street. Today the annex building serves as the Kanawha County Board of Education offices. The original Kanawha School was demolished, and the site now is a parking lot.

**BIGLEY SCHOOL.** Bigley School was built in 1907 on the northern end of Bigley Avenue. It looked very similar in design to other grade schools built about the same time, such as Kanawha and Tiskelwah. Bigley School was torn down in the 1970s as part of the construction of Interstates 77 and 79.

Coyle & Richardson Building, Charleston, W. Va.

**COYLE AND RICHARDSON.** No commercial businesses existed in the present 200 block of Capitol Street until about 1890, when J. Lynn Richardson and George Fayette Coyle built a store at the corner of Quarrier Street. Coyle and Richardson had first opened in 1884 in the Cotton Block on Kanawha Street between Capitol and Hale Streets. After stints in two locations in the 200 block of Capitol Street, Coyle and Richardson opened the department store shown in this postcard at the corner of Capitol and Lee Streets in 1907. While the store occupied the first two floors and the basement, the third through sixth stories were rented as office space. After Coyle and Richardson moved to the corner of Dickinson and Lee Streets in 1924, the National Bank of Commerce moved into this building. The structure was renovated in 1999 and now is home to the Chesapeake Bagel Bakery. It is listed in the National Register of Historic Places.

**YMCA.** Charleston's Young Men's Christian Association was organized officially in 1888 above the Ruby Brothers' grocery store on Capitol Street. In 1893, the association renovated the Norvell residence on Capitol Street, opposite the capitol, as its first permanent home. In 1907, a lavish Italian Renaissance building was erected on the same lot. The building was formally dedicated in 1911 and closed in 1980, when the YMCA moved to Hilltop Drive.

**FRANKENBERGER'S, 1908.** Jewish immigrant Moses Frankenberger opened his first Charleston clothing store in 1860. He was joined several years later by his brother, Philip. The Frankenbergers were among the city's largest landowners and operated several businesses. They moved into the store at the bottom right of this postcard in 1895. Philip's sons moved the business to Capitol Street in 1915. The site of the store in the postcard now is occupied by the Charleston House Holiday Inn.

6753—
Capitol Street
Charleston,
W. Va.

SCOTT BROTHERS DRUG STORE. Many Charlestonians will recall the Scott Brothers Drug Store at the corner of Capitol and Fife (now Brawley Walkway) Streets in the 1950s. It actually began in 1886 at the corner of Capitol and Virginia Streets. From about 1893 to 1914, the Scotts' store was at 124 Capitol Street (second awning from the right). This building was also the first site of Major's Bookstore.

Broad Street, Charleston, W. Va.

BROAD STREET, 1908. Broad Street was heavily residential until the 1920s. The oldest building on Broad Street was the house on the northwest corner of Kanawha Street. It was built in the early 19th century by Andrew Donnally and was the birthplace of Charleston's first mayor, Jacob Goshorn. It was torn down during the Kanawha Boulevard construction in the late 1930s. The United Carbon Building now stands on the site. Broad Street was renamed for Charleston native and civil rights leader Leon Sullivan in 2000.

**STATE STREET METHODIST CHURCH.** When the Methodist church split over slavery in 1844 (see page 16), Charleston's Northern faction continued to meet in the Asbury Chapel, which had been built on Virginia Street in 1834. In 1874, the Northern Methodists dedicated this church on the northeast corner of Court and State (now Lee) Streets, the current location of Laidley Tower.

**STATE STREET SYNAGOGUE.** As the reverse of the previous card shows, the Methodists held their final meeting on State Street in 1908. They sold the building to Charleston's Orthodox Jewish congregation. The rapid growth of the city's Jewish population had created two thriving congregations. Reformed Jews worshipped at the Virginia Street Temple from 1894 to 1960, dedicating the current B'Nai Israel Temple in 1960. Orthodox Jews moved from the State Street Synagogue to the current B'Nai Jacob Synagogue in 1950.

**CHRIST CHURCH UNITED METHODIST.** The Northern Methodists met in the YMCA from 1908 until 1911, when the First Methodist Episcopal Church was dedicated on the southwest corner of Quarrier and Morris Streets. After Methodists united nationally in 1939, the name was changed to Christ Church Methodist and then to Christ Church United Methodist in 1968. A devastating fire gutted the building in 1969, and the church was rebuilt on the same site. The original bell tower still exists.

**FLEETWOOD HOTEL.** The Fleetwood Hotel opened at 219 Capitol Street in 1909. In its early days, national figures including labor leader Mary "Mother" Jones stayed at the hotel. An overpass later expanded the Fleetwood to include a separate entrance on Summers Street. The Fleetwood became a low-rent hotel after a 1936 fire and closed in the early 1950s. Beside the Fleetwood in the postcard is Dreamland, one of Charleston's first movie theaters.

**THE 200 BLOCK OF CAPITOL STREET, 1909.** With the exception of the second building from the corner, the buildings on the right still stand. The corner building, the first business on the block, was built by Coyle and Richardson as a dry goods store about 1890. This building was later the second home of Kanawha Banking and Trust. W. A. Cantrell's music store was at 204 Capitol Street, flanked on the right by Charleston Hardware at 206 Capitol Street. Previously 206 Capitol Street had been the location of hardware stores owned by the Loewenstein brothers and the Goshorn brothers. Some may remember this as the first home of Embees. When it opened in 1895, the four-story brick building occupying 210 and 214 Capitol Street was the site of two of the state's largest clothing stores: Schwabe and May and Jelenko Brothers and Loeb. Schwabe and May opened originally on Kanawha Street in 1880. It remained at 210 Capitol Street for nearly 40 years before moving to Quarrier Street and then to its current store in the Charleston Town Center. Jelenko Brothers and Loeb went bankrupt after the devastating February 1897 flood. When this postcard was published, the Grand Rapids Furniture Company was at 214 Capitol Street.

**CAPITOL STREET, 1910.** This postcard looks north on Capitol Street from the intersection of Kanawha Street. In the 1870s, this was the first block of Capitol Street to be developed commercially. With the exception of the Terminal Building on the corner, the structures on the right were constructed primarily in the 1880s and 1890s. The oldest was the city's first five-and-dime, operated by F. J. Daniels at 16 Capitol Street.

**SPRING HILL CEMETERY.** Many of Charleston's earliest and most prominent citizens are buried in Spring Hill Cemetery. With Catholic and Jewish subdivisions, Spring Hill's tombstones paint a vivid history of Charleston from settlement days to the present. The city incorporated the cemetery in 1870, and the mausoleum was constructed in 1910.

**J. C. McCrory's and O. J. Morrison's.** The left side of this postcard shows two longtime Charleston businesses that started in the early 20th century. J. C. McCrory's, one of Charleston's first chain stores, opened in the first block of Capitol Street about 1903 but moved to 218 Capitol Street in 1905. In the 1920s, McCrory's was remodeled as the two-story building that still stands. McCrory's and other Capitol Street five-and-dimes had popular soda fountains, which were the scenes of some of the nation's earliest civil rights sit-ins in the 1950s. In 1999, McCrory's moved across the street to 209 Capitol Street and went out of business shortly thereafter. O. J. Morrison had operated stores in Kenna and Ripley before opening a department store at 214–216 Capitol Street in 1910. Morrison was a local pioneer in buying large quantities of goods at low prices and passing the discounts along to consumers. During the violent Paint Creek–Cabin Creek strike of 1912–1913, Morrison showed his support by supplying weapons to coal miners. In 1920, Morrison moved into a new building at 231 Capitol Street, where his department store continued to thrive until the 1980s.

**TERMINAL BUILDING.** The National City Bank built the eight-story Terminal Building on the northeast corner of Kanawha and Capitol Streets in 1910. The bank, which had been established at another site on Kanawha Street in 1907, occupied the first floor only. The top seven stories were used as office space. The largest tenant initially was the K&M Railroad Company, which rented the top three floors. The building slightly visible to the right was known as the Cotton Block, built by Dr. John Cotton in 1884. Both the Terminal Building and Cotton Block still stand. Prior to the Terminal Building, Henry Smith's Philadelphia One Price Clothing House stood at the corner of Kanawha and Capitol Streets for nearly 25 years.

**TISKELWAH.** Charleston expanded its city limits to Patrick Street in 1907. To accommodate the increasing population, the city built several new West Side schools. The first was Lincoln, which opened as a grade school in 1898 and became a junior high school in 1918. Tiskelwah was dedicated as a grade school on Florida Street and 7th Avenue in 1910. It closed in 2000 and now is a community center.

*STONEWALL JACKSON* **STATUE.** The statue of Confederate general Thomas "Stonewall" Jackson, a Clarksburg native, was dedicated on the capitol lawn on September 27, 1910. The monument was sponsored by the local United Daughters of the Confederacy chapter and sculpted in Rome by Moses Ezekiel. The statue was later moved to the current capitol complex.

**THE COG CITY.** Charleston issued this postcard about 1911 to promote its short-lived nickname, "the Cog City." By that time, numerous coal, oil, and gas (COG) companies had established headquarters in the centrally located capital city. At one time, there was even a Cog City Orchestra.

**FEDERAL BUILDING.** In 1911, a new federal building and post office was constructed to replace the 1884 customhouse. The post-office function was separated in 1942, but the facility continued to serve as a federal building until 1965. Since 1967, this has been the Kanawha County Public Library.

*Hubbards Court, Washington Street, Charleston, W. Va.*

**HUBBARD COURT.** Charleston's population explosion in the early 20th century made vacant lots hard to come by. The need to maximize residential space inspired real-estate developers to build fashionable town houses with shared courtyards. Hubbard Court, built about 1911 on Washington Street, was one of downtown Charleston's first courtyard complexes. It now is the site of the Clay Center for the Arts and Sciences.

*Kanawha River from Alderson-Stephenson Building, Charleston, W. Va.*

**UNION BUILDING.** When it was completed in 1911, the Alderson-Stephenson was the state's tallest building. Named originally for financiers Charles Alderson and Samuel Stephenson, the structure soon became known as the Union Trust Building. After the Union Trust Company went bankrupt during the Depression, the name was shortened to the Union Building. When the Kanawha Boulevard was built, this was the only structure spared on the south side of the street.

**SOUTH HILLS.** While the vista from Bridge Road has changed over the years, it always has offered a remarkable view of downtown Charleston. South Hills was sparsely populated until the South Side Bridge opened in 1891. Within 10 years, the area included nearly 100 houses, Fernbank School, and St. Matthew's Episcopal Church. South Hills was annexed by Charleston in 1907 and soon became the city's most opulent district.

**UNION MISSION.** In 1911, Pat Withrow founded the Union Mission shelter for destitute men at Lovell (now Washington) and Clendenin Streets. When the Union Mission relocated to 200 Washington Street six years later, the old building became a department store, selling donated items to raise money for the mission. The Union Mission survives nearly 100 years later with a large complex on South Park Road in Kanawha City.

**F. W. WOOLWORTH, 1912.** The F. W. Woolworth and Co. 5 and 10¢ Store (on the right) was one of Capitol Street's most popular five-and-dimes; however, it always will be remembered for a tragic fire. On March 4, 1949, while the Woolworth building was engulfed in flames, a floor collapsed, killing seven firemen. A new Woolworth Building was erected on the site and dedicated to the heroic firemen.

**CHARLESTON PUBLIC LIBRARY.** The city's library had five homes in 13 years: the YMCA (1909); the First Presbyterian parsonage (1912), as shown in this postcard; the YWCA (1913); a building at Virginia and McFarland Streets (1914); and the Red Cross building (1921). In 1926, the Charleston (now Kanawha County) Public Library moved into the former Capitol Annex, where it remained until 1966. The library opened in its current location, the old federal building, in 1967.

**CAPITOL THEATER.** The Plaza Theatre opened at 123 Summers Street as a vaudeville house in 1912. The theater closed in 1919, was remodeled, and reopened as the Capitol in 1921. After a fire in 1923, the theater became a movie house and continued in operation until 1982. Today the theater has been restored and is operated by West Virginia State University as the Capitol Plaza Theater.

**MOUNTAINEER STATUE.** This statue was dedicated December 10, 1912, on the state capitol grounds. The project was initiated by the Grand Army of the Republic and Women's Relief Corps. Intended to depict the quintessential West Virginia mountaineer, the statue's inspirations were two Webster County brothers—Eli "Rimfire" Hamrick and Ellis Hamrick. Like the statue of Stonewall Jackson, the *Mountaineer* now stands on the current capitol complex.

**CAPITOL AND LEE STREETS, 1913.** The foreground of this postcard shows the Lee Street Triangle, the last remaining remnant of the old capitol lawn. On the left is the Coyle and Richardson store. On the right is the Odd Fellows building, home to the Capital City Commercial College and Walter Eisensmith's jewelry store. Beside it is Prentice Ashton and Floyd Major's poolroom and newsstand. The brick building in the distance is the Burlew Opera House. Noyes Burlew, who began operating a local hardware store in 1872, wanted Charleston to have a first-class theater. In 1889, he built the 1,500-seat opera house, one of the state's largest. Over the years, the Burlew featured great actors, including Sarah Bernhardt and Lionel Barrymore, and orators such as Booker T. Washington. The growing popularity and number of movie theaters in the 20th century eventually put the Burlew out of business. In 1920, it was torn down and replaced with the O. J. Morrison Department Store.

ENTRANCE, LUNA PARK, CHARLESTON, W. VA.

**LUNA PARK.** West Charleston owes its strange street configurations to a popular amusement park that existed for only 10 years. Luna Park opened on June 14, 1913, on the grounds of the former Glenwood Athletic Club golf course in an area bounded by the Kanawha River, Grant Street, Park Drive, and Glenwood Avenue. The main entrance was at the corner of Grant Street and Park Avenue.

ROLLER COASTER, LUNA PARK, CHARLESTON, W. VA.

**ROYAL GIANT DIPS COASTER.** The daring design of wooden coasters nearly 100 years ago elevated amusement parks to another level from just swings and merry-go-rounds. Luna Park's coaster, the Royal Giant Dips, wound through every section of the park. Unfortunately it burned down with the rest of the park in May 1923. The park's ravines were filled with dirt, its walkways were converted into streets, and the site was sold for housing.

69

**ST. FRANCIS HOSPITAL.** Salt maker and attorney James M. Laidley moved into this house on Laidley Street after selling his Glenwood estate in 1857. In December 1912, his daughter Rowena Laidley sold the building to Catholic bishop P. J. Donahue. St. Francis Hospital opened the next year but quickly outgrew the confines of the antebellum Laidley house.

**ST. FRANCIS HOSPITAL.** The hospital replaced the Laidley homestead with this 42-bed facility in 1917 and added a nursing program in 1939. In 1951, St. Francis became one of the first hospitals in the region to integrate its nursing program. The building shown in the postcard was torn down in 1986. The Hospital Corporation of America now operates St. Francis as a 155-bed facility.

**MCMILLAN HOSPITAL.** Canadian-born William McMillan moved to Charleston and began practicing medicine in 1903. Ten years later, he founded a hospital at the corner of Elmwood Avenue and Jacob Street but soon moved into this building on the southeast corner of Morris and Lee Streets. McMillan also established a training program for nurses. The hospital merged with Charleston General in 1971.

**HOLLEY HOTEL.** The Holley Hotel opened in 1914 at 1008 Quarrier Street. The Holley originally featured mahogany and brass finishes; however, more modern hotels eventually made the Holley obsolete. In the 1970s, owner Frankie Veltri began offering free Thanksgiving meals at the Holley, which had become a low-rent facility. The Holley was imploded in 1993, and Veltri died in 2001; however, local residents continue his Thanksgiving tradition.

**A. W. Cox Department Store.** In 1914, A. W. Cox opened a department store at 222 Capitol Street in the first building on the left. Cox also was a cofounder of the Diamond in 1927. The A. W. Cox Department Store closed in 1984 at another location. Previously this building, known as the Bradford, had housed Coyle and Richardson's dry goods store and the White Elephant saloon.

**Security Building.** Kanawha National Bank and Frankenberger's jointly built this high-rise on the northeast corner of Capitol and Virginia Streets in 1914. It opened the following year. Kanawha National failed after the 1929 stock market crash and merged with Charleston National Bank. In 1931, Security Bank and Trust moved in beside Frankenberger's, inspiring the name Security Building. Frankenberger's closed in 1983, ending a 123-year business run interrupted briefly by the Civil War.

UNITED FUEL GAS BUILDING, CHARLESTON, W. VA.

**UNITED FUEL GAS.** The United Fuel Gas Building was built in 1915 on the southeast corner of Quarrier and Dunbar Streets. The company, founded in 1892 as the Charleston Natural Gas Company, laid the city's first gas lines. In 1928, the company added four stories to this building, which still stands. In 1957, United Fuel (later Columbia Gas Transmission) moved to an 11-story building in South Ruffner.

VIEW OF CHARLESTON, W. VA. FROM UNION BUILDING SHOWING KANAWHA RIVER.

**COAL MINING EQUIPMENT.** This 1915 postcard shows the Southern Mine Supply building adjacent to the South Side Bridge at 908 Kanawha Street. In the early 20th century, Charleston was a manufacturing center for the coal industry. One of Charleston's most enduring businesses started in this field. In 1902, the Kanawha Mine Car Company was founded near the K&M tracks on the East End. In 1915, it became Kanawha Manufacturing and still exists.

73

CAPITOL STREET, SOUTH FROM POST OFFICE SQUARE, CHARLESTON, W. VA.

**S. SPENCER MOORE'S AND KAUFMAN'S.** The left side of this 1915 Capitol Street postcard shows two of Charleston's most venerable businesses: S. Spencer Moore's and Kaufman's Clothing. Moore's opened as a printer on Kanawha Street in 1863. Located at several sites, Moore's finally moved to 118 Capitol Street about 1890 and obtained a Kodak franchise. For much of the 20th century, Moore's was known equally for books, magazines, and fine photographs. Moore's closed in 1987, ending 124 continuous years in business. The store originally published many of the postcards in this book. In 1905, Harry and Grover Kaufman moved to Charleston from South Boston, Virginia, and established a clothing store at 716 Kanawha Street. They moved to the store in the left foreground at 122 Capitol Street in 1911 and were joined in business by a third brother, Lawrence. They expanded into the adjoining storeroom at 120 Capitol Street in 1933 and remained a downtown fixture until closing in 1967. Other longtime businesses featured in this postcard include Walter Builtman's pharmacy (between Moore's and Kaufman's) and an ad for Nu-Way Cleaner, which was located on Summers Street.

VIEW OF BLAINE'S ISLAND AND KANAWHA RIVER, NEAR CHARLESTON, W. VA.

**BLAINE ISLAND, 1915.** This postcard shows Blaine Island and South Charleston at the beginning of the chemical industry boom. In 1914, Rollins Chemical Company (later Barium Reduction) moved to South Charleston, followed by the Warner-Klipstein Company (later Westvaco), which made chlorine and caustic soda. The industry quickly took off when the outbreak of World War I cut off all German chemical products.

Route 60 thru South Charleston, W. Va.

**BLAINE ISLAND, 1950s.** In 1925, the Carbide and Carbon Chemical Company (later Union Carbide) moved to South Charleston from Clendenin. When the company relocated to Blaine Island three years later, South Charleston became the largest chlorine manufacturer in the world. This 1950s postcard shows South Charleston at the height of its chemical production. In 2001, Union Carbide became a subsidiary of Dow Chemical.

EAST CHARLESTON BRIDGE AND KANAWHA RIVER, CHARLESTON, W. VA.

**KANAWHA CITY BRIDGE.** In 1915, a new bridge was completed, connecting the city's streetcar line between the East End and Kanawha City. At the time, Kanawha City was sparsely populated and swampy in many places. The only industry was the Columbia Barbed Wire and Nail Works. In addition, the area was used for National Guard encampments and as a staging area by Gen. Billy Mitchell, whose U.S. Army Air Service attempted to drop bombs on marching miners in Logan County during the 1921 labor insurrection. After the Kanawha Land Company purchased Kanawha City, the region began developing quickly. Developer Isaac Noyes Smith, who owned two-thirds of Kanawha City, laid out the streets and lined them with trees, many of which still stand. By the 1940s, Kanawha City had become Charleston's fastest-growing suburb. The Kanawha City Bridge was demolished in 1975 and replaced with two one-way bridges at Thirty-fifth and Thirty-sixth Streets.

**LIBBEY-OWENS SHEET GLASS PLANT.** In 1917, the Libbey-Owens Sheet Glass Company was established on the site of the current Kanawha City Mall. By 1923, it had become the largest glass factory under one roof in the world. In 1929, Ford Motor Company bought an interest in the business. Libbey-Owens-Ford closed in 1980, and the giant smokestacks were toppled. All that remains of the world's once-largest glass factory is the building on the left.

**OWENS BOTTLING PLANT.** Michael Owens, who cofounded the sheet-glass plant, also invented an automatic bottling machine, sparking a revolution in the beverage industry. In 1917, he opened this massive bottling plant on the left opposite the sheet-glass factory. The company became known as Owens-Illinois after a merger in 1929. The plant closed in 1964.

*Boyd Memorial Christian Church, Charleston, W. Va., Delaware at Randolph*

**BOYD MEMORIAL CHRISTIAN CHURCH.** The development of suburbs created a construction boom for neighborhood churches, particularly on the West Side. Boyd Memorial Christian Church was organized on Indiana Avenue on November 6, 1916, with 66 members. This $200,000 building was dedicated at Delaware and Randolph Avenues in 1917. The church remains a place of worship.

*Humphreys Methodist Church, Charleston, W. Va.*

**HUMPHREYS MEMORIAL METHODIST CHURCH.** The Roane Street Methodist Episcopal Church, South, was organized in 1893. The first lot was funded primarily by member James Humphreys. In 1909, the renamed Humphreys Memorial Methodist Church relocated to the corner of Roane Street and Maryland Avenue. The building shown here was completed in 1917 and still is in use as the West Side United Methodist Church. The light fixtures in front of the church once stood on the old capitol lawn.

**BIRTH OF A NATION.** In 1917, the Morrison Building was built on the southwest corner of Quarrier and Hale Streets. One of its original tenants was the Rialto Theatre. In 1925, African American leaders protested the showing of D. W. Griffith's film *Birth of a Nation* at the Rialto because it violated a state law banning entertainment demeaning to another race. In a landmark ruling, the state supreme court blocked the movie's screening.

**KANAWHA BANKING AND TRUST.** In 1918, Kanawha Banking and Trust (KB&T) constructed the tower on the right, on the former site of the Charleston National Bank. KB&T was Charleston's first bank with a savings department. The bank, founded in 1901, was originally located at 13 Capitol Street before moving to the corner of Capitol and Quarrier Streets, then to the location shown in this postcard. KB&T closed in 1985, and the building was converted into condominiums.

CAPITOL STREET NORTH FROM POST OFFICE, CHARLESTON, W. VA.   71272

**Capitol and Quarrier, 1918.** This 1918 snapshot shows one of Charleston's busiest intersections: Capitol and Quarrier Streets. The billboard promoting the effort to win World War I was located in the courtyard between the federal building and Charleston National Bank. Quarrier Street was not extended through to Summers Street until 1958. An American flag hangs in front of the Citizens National Bank on the right. The bank, organized in 1890, completed this building in November 1899. It supposedly was the first fireproof building in town and featured marble stairways, brass railings, tile floors, and a public elevator. The building was later home to two longtime Charleston businesses. Berman Jewelry occupied the location from about 1950 to 1988. Sam Berman had established his first jewelry store in Clendenin in 1893. In 1902, he moved to present Washington Street on the West Side and then to 605 Kanawha Street. His sons I. J. and Marcus made the move to Capitol Street. The longest lasting business on this site is the Peanut Shoppe, which has operated in the right part of the building since 1950.

# Four

# A SUBURBAN CITY
## *1920–1949*

Charleston changed forever when the state capitol burned down in 1921. The fire altered the look of downtown Charleston as dramatically as the capitol's arrival had in 1885. The destruction of the capitol and a subsequent capitol fire in 1927 also cleared away land for several well-remembered Charleston businesses.

The capitol's move to the East End represented a symbolic shift in Charleston, whose population and businesses were spreading away from downtown. For 130 years, Charleston was synonymous with the downtown area. Although this perception had been changing, it became more profound with the annexation of Kanawha City and South Ruffner in 1929 and North Charleston in 1948.

Like the rest of the country, Charleston was devastated by the Great Depression. Other than banks and coal companies, most businesses survived; however, many Charlestonians suffered. Although not reflected in these postcards, the hardest hit areas were poor communities, particularly on the northern and western ends of the downtown. Some of these areas, such as the section known as the Triangle, never recovered fully.

In response to the Depression, New Deal legislation poured federal funding into Charleston, resulting in new buildings, bridges, and roads. The New Deal also addressed poor housing in the city by funding Washington Manor and Littlepage Terrace, which were among the first federally funded inner-city housing projects in the country.

Between 1920 and 1930, Charleston's population jumped by more than 50 percent, from 39,608 to 60,408. By the end of the 1940s, Charleston had 73,501 residents, second in the state only to Huntington.

**CAPITOL IN FLAMES.** Shortly after 3:00 on the afternoon of January 3, 1921, people strolling on the sidewalk noticed smoke emanating from the top windows of the capitol. Within minutes, the entire building was engulfed in flames. The fire's origin never has been determined. Speculations about the cause range from arson to workers rolling dice by candlelight.

**FIGHTING THE FIRE.** The city fire department arrived within minutes, stringing hoses from an old steam engine and a modern truck. The firemen were hindered by the intense heat, two gas explosions, and rounds of National Guard ammunition that ignited on the top floor. Falling debris killed fireman Charles Walker and injured others.

**TOTAL DESTRUCTION.** This photograph shows the capitol at the peak of the fire. The destruction was overwhelming, and very little was salvaged. The state used the insurance money from the fire to hastily construct a temporary clapboard building, later known as the "pasteboard capitol," across the street.

**RISING FROM THE RUINS.** Even before the ruins had been carted away, the governor appointed a capitol building commission. It purchased land on the East End and contracted architect Cass Gilbert to design a new capitol. As for the old structure, contractors demolished the remaining walls and bulldozed the lot. By the end of the 1920s, the old capitol lawn would be the site of the new Kanawha Valley Bank and the Diamond.

*Armory Skating Rink, Charleston, W. Va.*

**ARMORY.** After the capitol fire, state officials scrambled to find temporary offices in at least 14 downtown buildings. The governor, secretary of state, adjutant general, and several other departments moved into the Armory, which was used more typically for skating, concerts, and Charleston High School basketball games. This building, which still stands at 404 Capitol Street, later became the Scottish Rite Cathedral.

*Mountain State Hospital, 1301 Virginia Street, Charleston, West Virginia.*

**MOUNTAIN STATE HOSPITAL.** A group of local physicians, pharmacist George Kenney, and state attorney general E. T. England founded the Mountain State Hospital in 1921. They purchased this building on the southeast corner of Virginia and Morris Streets and opened a 120-bed for-profit hospital. It went out of business in 1971. The building was torn down in 2005.

**SUPERIOR LAUNDRY.** Charles B. Young founded Young's Laundry in 1921 but soon changed the name to Superior. Fronting on Kanawha Street (now Boulevard), Superior Laundry took up most of the block between Truslow and Goshorn Streets. This block today is occupied by the Spilman, Thomas, and Battle law firm.

**KEARSE THEATER.** When the Kearse opened on Summers Street in 1922, it was the largest movie house in the state. In this 1922 postcard, the movie feature was *When Love Comes,* starring silent film stars Helen Jerome Eddy and Harrison Ford. The theater closed in December 1979 and burned in 1982 while awaiting demolition. This site now is a parking lot. The Kearse is listed on the National Register of Historic Places.

**CITY HALL.** On August 31, 1922, Charleston dedicated its current city government building on the southeast corner of Court and Virginia Streets. It was built on the site of the first permanent city hall, constructed in 1884. The new building was designed by architect H. Rus Warne of Charleston and now is listed in the National Register of Historic Places.

**CHARLESTON POLICE DEPARTMENT.** During evangelist Billy Sunday's 1922 rally, he posed (holding hat in center) with the Charleston Police Department. Sunday is flanked by Gov. Ephraim Morgan (to his left) and Police Chief J. M. Craigo (to his right). In 1912–1913, Craigo had been on the other side of the law as a union leader during the Paint Creek–Cabin Creek coal strike. On the second row at far left, is N. N. Willis, one of the city's first African American patrolmen.

86

**SCHOOLS OF CHARLESTON.** Charleston's growing population and the push for junior high schools produced several new schools in the 1920s. Roosevelt Junior High, pictured here, was built on Ruffner Avenue in 1922. Also in 1922, Glenwood was opened as a grade school at Glenwood Avenue and Grant Street. The third school in the postcard, at the corner of Morris and Quarrier Streets, served as Charleston High School from 1915 to 1926. When the new Charleston High School opened on Washington Street, this building became Thomas Jefferson Junior High School. Today Roosevelt serves as a community center, and Glenwood remains a grade school. The Thomas Jefferson building still stands but is empty. Other new schools built during the 1920s included Woodrow Wilson Junior High School, Kanawha City High School (later known as Chamberlain Junior High and Elementary School), and Boyd Junior High School and Garnet High School for African Americans.

**VIRGINIA STREET, 1923.** This view looks west on Virginia Street from Hale Street. All the buildings on the right still stand; from front to back, they are the Masonic Temple; the Guthrie, Morris, and Campbell Building; and the Security Building. Most of the buildings visible on the left were destroyed in the January 1946 Rose City Press fire.

**YWCA.** A group of women from the Baptist Temple organized Charleston's Young Women's Christian Association in 1912. The YWCA's goal was to provide clean, temporary living quarters for women. The organization later became a leader in fighting domestic violence. Charleston's YWCA began construction of this building on Quarrier Street in 1919 and dedicated it in 1923.

**LAIDLEY FIELD.** The city's oldest sports stadium is Laidley Field, which was established around 1915. The facility was upgraded with the installation of permanent stands in 1924. The year before, the stadium's wooden stands had collapsed during a West Virginia University football game. Over the years, it has been the football home for every city high school, Morris Harvey College, and the University of Charleston.

*Governor's Mansion, Charleston, West Virginia*

**GOVERNOR'S MANSION.** Gov. Ephraim Morgan moved into the newly completed governor's mansion on February 27, 1925, less than a week before ending his term. Morgan became the last governor to occupy the first governor's mansion and first to occupy the current mansion. Charleston architect Walter Martens designed the Georgian Colonial building, which was erected near the west wing of the new capitol.

**CAPITOL WEST WING.** In May 1925, the west wing of the new state capitol was completed, followed two years later by the east wing. Most state offices and records were moved to the new wings, preserving documents that would have been destroyed in the 1927 pasteboard capitol fire. In this 1950s image of the building, notice the capitol fountain, designed by Cass Gilbert Jr. It was completed in 1946. (Photograph by Jack Taylor.)

**DUPONT.** In 1926, E. I. DuPont de Nemours built this $27-million factory at Belle on the site of early salt works. The plant increased ammonia production from 25 tons per day in 1926 to 220 tons in 1929. In 1939, the Belle facility, DuPont's largest at the time, played a significant role in the development of nylon, the first synthetic textile. Today the Belle plant is a large manufacturer of fertilizer components.

**WCHS OLD FARM HOUR CHARLESTON, W. VA.**

**WCHS.** On September 15, 1927, Walter Fredericks launched WOBU as Charleston's first radio station and only the third in the state. WOBU soon changed its call letters to WCHS and moved from its Ruffner Hotel studio to the Middleburg Auditorium. The Friday night "Old Farm Hour" featured local talent performing before a live audience of about 2,000. The show was hosted first by Buddy Starcher then by Frank Welling.

**WCHS.** In the early days, radio stations competed by hiring well-known musicians on exclusive, although temporary, contracts. The influential Delmore Brothers, an Alabama duo who had been on the Grand Ole Opry, worked for WCHS for a short time in 1939. WCHS also helped launch the careers of local performers, including the Bailes Brothers, Kessinger Brothers, Lilly Brothers, and "Red" Sovine.

**LOUDEN HEIGHTS.** This 1905 postcard shows an unpaved Louden Heights Road. Although Judge James Ferguson had built the first house on Louden Heights in 1883, this section of South Hills did not develop rapidly until the 1920s. Farther up this road, at the intersection with Bridge Road, stands one of Charleston's oldest structures, the William Gilliland cabin, which dates to about 1847.

**FORT HILL.** This 1929 postcard shows a view of downtown from Fort Hill. Like Louden Heights, Fort Hill had only a few scattered houses until a late-1920s housing boom. The area's name is derived from Fort Scammon, built on top of the hill in 1863. The year before, Confederates had used this position to fire artillery rounds at Union troops during the Battle of Charleston.

**KANAWHA VALLEY BUILDING, CHARLESTON, W. VA.**

**THE DIAMOND AND KANAWHA VALLEY BANK.** The burning of the old capitol made way for two Charleston fixtures: the Diamond and Kanawha Valley Bank buildings. The Diamond had been in business as the Diamond Garment and Shoe Company since 1906, first on Kanawha Street and finally at 209 Capitol Street. Cofounders Wehrle Geary and A. W. Cox realized Charleston was ready for a modern department store and opened the Diamond at the corner of Washington and Capitol Streets in 1927. The Diamond was Charleston's most popular department store for decades, closing in May 1983 due to competition from the Charleston Town Center. When built in 1929, the 20-floor Kanawha Valley Bank building was the tallest structure in the state, a record held only until 1932, when the new capitol was dedicated. Kanawha Valley Bank moved to a new skyscraper at Lee and Summers Street in 1976. In the 1980s, Kanawha Valley Bank became One Valley, which later was acquired by BB&T. Throughout most of the 20th century, Kanawha Valley was either the largest or second largest state-chartered bank in West Virginia.

### The Daniel Boone

In beautiful West Virginia, the Switzerland of America. Attractive 11 story, fire proof hotel was erected by the citizens of Charleston, W. Va., at a cost of two and one-half million dollars in memory of Daniel Boone, famous pioneer and scout of nearly 200 years ago. Located in the center of the city and just a short distance from the State Capitol. 465 rooms, each with bath, circulating ice water and radio loud speaker. 281 rooms and all public space completely air conditioned. You will like the homelike atmosphere of the Daniel Boone.

ROGER S. CREEL
*Managing Director*

**DANIEL BOONE HOTEL.** Another capitol fire cleared the way for one more Charleston landmark. Developers built the Daniel Boone Hotel on the corner of Capitol and Washington Streets, the site of the destroyed pasteboard capitol. The 10-story hotel was completed in 1929 and immediately became the city's leading hotel. This postcard from the 1950s shows the hotel in its heyday.

**DANIEL BOONE HOTEL.** The Daniel Boone was widely known for fine dining and the 1791 Tavern. It hosted national politicians, athletes, and entertainers ranging from Bob Hope to Bob Dylan. After a concert in 1975, Elvis Presley and his entourage occupied 63 rooms at the Daniel Boone. Competition from chain hotels eventually took a toll on Charleston's old hotels. The Daniel Boone closed in 1981 and was renovated into an office building.

**THE SCLOVES.** This late-1920s Capitol Street postcard shows a view toward the Union Building. On the right is the store of Louis and Bertha Sclove. Emigrating from Russia in 1906, they were among a large group of Jewish immigrants who settled in Charleston around the turn of the 20th century. The Scloves were successful merchants for many years, Louis as a jeweler and watchmaker and Bertha as a milliner.

**EDWARD J. COLEMAN.** The man seated in this postcard presumably is Edward J. Coleman. An experienced shoeshine man, Coleman started the West Virginia Shine Company at 615 Dryden Street in 1913. About 1920, he relocated to this building at 601 Dryden and added tailoring and laundering services. Coleman was one of many African Americans who owned businesses on the north side of town, an area now covered by Interstates 64 and 77.

**KANAWHA COUNTRY CLUB.** In 1930, after a fire destroyed the original building, the Kanawha Country Club completed this new clubhouse. Formed originally in 1921, Kanawha Country Club built the county's first 18-hole golf course near South Charleston in 1935. In 2005, the city of South Charleston opened the site as a public golf course.

**CASS GILBERT'S CAPITOL.** New York architect Cass Gilbert had a grandiose vision for West Virginia's new capitol, including courtyards, statues, a reflecting pool, and this redeveloped waterfront. Due to financial constraints during the Great Depression, most of Gilbert's landscaping ideas never came to fruition.

REAR—NEW STATE CAPITOL, CHARLESTON, W. VA.

**WEST VIRGINIA STATE CAPITOL.** Gov. William Conley dedicated the new capitol building on June 20, 1932. The dignitaries who spoke on the capitol's north portico included Mother's Day founder Anna Jarvis. This photograph was taken from Hillcrest Drive shortly after construction was finished. Notice the lack of development across the river, where the University of Charleston currently is located. The capitol's west wing had been completed in 1925 followed by the east wing in 1927. Shortly before the 1929 stock market crash, the legislature levied a special property tax to complete the building. Work on the main unit, led by general contractor George A. Fuller Company of Cincinnati, began in April 1930. The limestone was quarried from Indiana, and the interior marble was obtained from Vermont. In the end, total construction costs reached nearly $10 million, even with some of Cass Gilbert's intentions eliminated. The crowning achievement was a gold-leaf dome that reached 293 feet—still West Virginia's tallest building and four feet taller than the U.S. Capitol.

NEW BRIDGE OVER THE KANAWHA RIVER AT CHARLESTON, W. VA.

**PATRICK STREET BRIDGE.** In 1932, the Patrick Street Bridge was completed for $850,000, connecting West Charleston and South Charleston. On the opposite end of the bridge (by the water tower on the left) was the Kelly Axe Factory, the world's largest manufacturer of edged tools. Another landmark business at the foot of the bridge was Shoney's, founded by Alex Schoenbaum in 1952. Today this is Charleston's oldest truss bridge still in use.

Rock Lake Swimming Pool, Stop 12, St. Albans Line, Charleston, West Virginia    25

**ROCK LAKE.** For more than three decades, one of the area's most popular attractions was Rock Lake Swimming Pool, located in nearby Spring Hill. It opened in 1933 on the site of the former South Charleston Crusher Company quarry, which had provided ballast rock for railroad beds since 1907. Rock Lake developers boasted the 400-by-200-foot pool could accommodate 7,500 swimmers at once. The owners closed the facility in 1966 to avoid admitting African Americans. It later reopened but closed again in 1985.

**HISSOM TABERNACLE.** At the height of the Great Depression, the Reverend Earl Hissom was possibly the first Charleston evangelist to discover the power of radio. During the 1930s, Hissom's radio broadcasts made him one of the region's most popular ministers. In 1934, he founded a nondenominational tabernacle on Garrison Avenue and began serving free annual Thanksgiving dinners to the needy. In 1951, Hissom moved the tabernacle to the corner of Pennsylvania Avenue and Spring Street. The Hissom Tabernacle still conducts worship services.

**SOUTH SIDE BRIDGE.** By 1936, the old South Side Bridge was considered obsolete and dangerous. After its demolition, the city briefly employed a ferry system to transport people across the Kanawha River. The current South Side Bridge was completed in 1937, using voter-approved bonds to match nearly $500,000 in federal Works Progress Administration (WPA) funds. At the time, it was one of the most expensive WPA projects in the country. (Photograph by Bennett's Studio.)

**FRANKLIN CAFE.** Jake Ellis's Art Deco-style Franklin Cafe was at 812 Kanawha Street (now Boulevard). Other than the Franklin Cafe, this building is best remembered for various saloons ranging from George Beller's and Charles Capito's establishments around the beginning of the 20th century to the Charleston Athletic Club in the 1970s. Today the building is occupied by the Sound Factory nightclub.

**PAULEY'S.** One of Charleston's favorite hangouts for young people was John Pauley's South Ruffner Coffee Shoppe, located on MacCorkle Avenue on the future site of Blackwell Field. Pauley's wide-ranging menu featured everything from steaks and fried chicken to spaghetti to chow mein. The Garden area was a popular gathering place known for its jukebox, dance floor, and beer.

**QUARRIER DINER.** Otmer, Roma, and Walter Young opened the first Quarrier Diner near the Holley Hotel in the early 1930s. The Youngs closed the restaurant several years later but built this café in 1947. For more than 50 years, the Quarrier Diner was a Charleston landmark noted for its good food and Art Deco-style Carrara Glass façade. The Quarrier Diner, later known as Young's Food House, closed in 1999.

**ROSE CITY CAFETERIA.** Bil Harold opened the Rose City Cafeteria at 162 Summers Street about 1923. It was named for a civic effort to promote Charleston's attractive rose gardens. The franchise grew to five restaurants, including cafeterias in the Holley Hotel and on Duffy Street. The last Rose City cafeterias closed on Lee Street in 1992 and in South Charleston in 1996.

101

Greyhound Bus Depot, Charleston, W. Va.

**GREYHOUND BUS STATION.** Arthur Hill founded Blue and Gray Lines in 1926, providing bus service from Charleston to Huntington and Gauley Bridge. Four years later, the company merged with Atlantic Greyhound. On January 30, 1937, Hill dedicated this Greyhound terminal on Summers Street. The new station, built by Charleston's H. G. Agsten and Sons, accommodated 24 buses and included a restaurant. Today this is the site of Slack Plaza.

**MUNICIPAL AUDITORIUM.** The 3,500-seat Municipal Auditorium opened in 1939 at the corner of Virginia and Truslow Streets. Designed by W. F. Wysong, the building was constructed in large part with WPA funding. For more than six decades, Municipal Auditorium was home to the Charleston Symphony Orchestra and its successor, the West Virginia Symphony Orchestra. (Photograph by Jack Taylor.)

*Charleston, W. Va. showing New Kanawha Boulevard*

**KANAWHA BOULEVARD.** The four-lane Kanawha Boulevard was completed from Patrick Street to downtown in 1938. A new bridge across the Elk River linked Columbia Boulevard on the West Side with the old Kanawha Street in the downtown area. This massive undertaking, funded in part by the WPA, required the demolition or relocation of numerous structures.

*Kanawha Boulevard from Kanawha City Bridge showing Capitol Dome, Charleston, W. Va.*

**KANAWHA BOULEVARD.** The boulevard was completed from downtown to the Kanawha City Bridge in 1940. The project landscaped the riverbank and added new sidewalks. For the first time, a straight roadway connected Charleston's eastern- and westernmost points.

*Kanawha Blvd. and Kanawha River, showing United Carbon Building and Riverview Apartments.*

**UNITED CARBON BUILDING.** In 1940, the 12-story United Carbon Building was completed at the corner of the new Kanawha Boulevard and Broad Street (now Leon Sullivan Way). The building served as the headquarters of the United Carbon Company. Designed by Charleston's Walter Martens and his son Robert, the structure blended industrial colors and motifs into an International style. It now is known as Boulevard Tower.

*Greystone Hotel Charleston, West Virginia*

**GREYSTONE HOTEL.** Traveling changed forever with the introduction of a complete air-conditioning system in the 1940 Packard. For the first time, summer vacationers could drive long distances without sweltering. The new wave of travelers gave rise to the overnight "motor hotel," or motel. George Martin operated this early motel near the Kanawha City Bridge on Route 60. The building now is owned by the Open Door Apostolic Church.

**CHARLESTON CATHOLIC.** Charleston Catholic High School was built in 1940 at the corner of Broad (now Leon Sullivan Way) and Virginia Streets, the site of an earlier Catholic high school constructed in 1923. The city's first Catholic school dated to 1867. In 1872, the Sisters of St. Joseph opened St. Joseph's (later St. Mary's) Academy at Broad and Quarrier Streets, now the location of Sacred Heart Grade School.

**STONEWALL JACKSON.** In 1940, Stonewall Jackson High School opened on West Washington Street, and West Side students transferred from Charleston High School to the new school. A third high school, George Washington, was built in South Hills in the 1960s. In 1989, after years of population decline, Stonewall and Charleston High Schools were combined into Capital High School. The building in the postcard now serves as Stonewall Jackson Middle School.

*Canteen . . . Charleston, (W. Va.) Service Center*

**THE CANTEEN.** During World War II, the American Red Cross Canteen Corps established a service center in Charleston providing coffee, doughnuts, and homemade snacks to military personnel passing through town by rail. At these stops, the Red Cross distributed free postcards like this one to military men and women. During the war, the Red Cross served an estimated 163 million cups of coffee and 254 million doughnuts nationally.

**U. S. POST OFFICE.** In June 1942, the post office was moved from the federal building into this new facility on Dickinson Street between Lee and Washington Streets. The post office has been enlarged several times, most notably in 1973, and comprises the entire block from Dickinson Street to Leon Sullivan Way.

Kanawha Airport, Charleston, West Virginia

**KANAWHA AIRPORT.** Although an airfield existed in Kanawha City before 1920, the valley's first passenger airport was Wertz Field, established at Institute in 1930. It closed in 1942, and the valley lacked air service for five years. In 1947, the $8.3-million Kanawha Airport opened on Coonskin Ridge with 10 daily flights. The administration building was completed in 1950. The airport now is named in honor of Lincoln County native Chuck Yeager. Two serious air disasters have occurred at the airport. On April 9, 1951, a National Guard C-47 crashed while attempting to land, killing 21 local guardsmen. The airport's deadliest disaster occurred when a Piedmont plane crashed on August 10, 1968, killing 35.

*Morris Harvey College Buildings, Charleston, W. Va.*

**MORRIS HARVEY COLLEGE.** On September 8, 1947, Morris Harvey College moved from its home in the public library (formerly the Capitol Annex) to South Ruffner. Morris Harvey had been founded as the Methodist Barboursville Seminary in 1888. The name was changed in 1903 to honor benefactor Morris Harvey. Under Pres. Leonard Riggleman, Morris Harvey expanded its offerings in the 1930s and dropped its affiliation with the Methodist Church. In 1935, Riggleman moved Morris Harvey from Barboursville to Charleston and established classrooms in the former Capitol Annex. The college took over two failing schools: Kanawha College in 1939 and the Mason College of Music and Fine Arts in 1956. At South Ruffner, the first buildings constructed were the gymnasium (right) and Riggleman Hall (left). The school later added the Geary Student Union, Clay Tower Building, Schoenbaum Library, and residence halls. In 1978, Morris Harvey College became the University of Charleston.

*Five*

# A Time for Urban Renewal
## *1950–Present*

Transportation improvements always have had the greatest impact on Charleston's economy and landscape. The city's most dramatic transportation changes occurred in the latter part of the 20th century. It started with the completion of the West Virginia Turnpike in the 1950s and ended with the interstate and corridor construction of the 1970s and 1980s. The new roads brought industry and tourists from across the country through the heart of Charleston. They also enabled people to work in Charleston while living in remote suburbs such as Putnam County's Teays Valley. The result was a mass population exodus.

Despite residents moving away, Charleston's population actually increased in the 1950s due to an extensive annexation in 1958. By 1960, Charleston had 85,796 citizens and, for the first time, was the largest city in West Virginia. Although Charleston retained this top ranking, the population dropped nearly 40 percent to 53,421 by the end of the century.

As people and businesses left Charleston, leaders gave the city a face-lift. Many of the once-proud buildings from the turn of the 20th century had become decrepit. An urban renewal effort began with the demolition of buildings along Kanawha Boulevard in the early 1960s and swept across town over the next 10 years. The most expansive demolition included the Triangle, which uprooted poor and largely African American residents from Laidley Street to the Elk River. Although the Civic Center was built in the Triangle in 1958, the much-anticipated "Super Block" did not become a reality until the 1980s, with the completion of the Marriott Hotel and the Charleston Town Center.

When it opened in 1982, the Town Center was the largest inner-city mall in the country. As anticipated, it quickly forced many longtime downtown businesses to close. Capitol Street, the heart of Charleston's commercial district since the turn of the century, had only a handful of remaining shops by the mid-1980s. The Charleston Renaissance organization began yet another urban renewal effort to restore the facades of Capitol Street's buildings, sparking renewed interest in the historic street. While Capitol Street's business climate is far from its glory days, a new generation of stores, restaurants, nightclubs, and office complexes has begun to revitalize downtown Charleston.

*Charleston Memorial Hospital, Charleston, W. Va.*

**CHARLESTON MEMORIAL HOSPITAL.** Charleston Memorial was dedicated in 1951 in memory of West Virginia soldiers who gave their lives during World War II. In 1972, the hospital merged with Charleston General Hospital and the former McMillan Hospital to become the Charleston Area Medical Center (CAMC). CAMC Memorial Hospital, as it is now known, has expanded greatly and is the headquarters for the Robert C. Byrd Health Sciences Center of West Virginia University.

*State Office Building Number Three, Charleston, West Virginia*

**THE CAPITOL COMPLEX.** Like the old capitol, West Virginia's new statehouse outgrew its confines in less than 20 years. In 1952, the Division of Motor Vehicles building, known as Building 3, was completed on Washington Street opposite the main capitol. Designed by Cass Gilbert Jr.—the son of the capitol's architect—Building 3 was the first of several office annexes that developed into today's large capitol complex.

**WEST VIRGINIA TURNPIKE.** In 1954, the West Virginia Turnpike was completed from Princeton to Charleston, ending with the Chuck Yeager Bridge and this horseshoe bend. Like the railroad in the late 19th century, the turnpike and other roads eventually connected Charleston with the rest of the state and the country. In the 1970s, the turnpike became a key link in Interstate 77, which extends from Cleveland to Columbia.

**HIGHLAND HOSPITAL.** Highland Hospital was chartered initially in 1955 as the Valley Convalescent Hospital. Located originally on Quarrier Street in downtown Charleston, the hospital helped patients with emotional and psychiatric problems. In 1960, Highland took over the Boiarsky Memorial Hospital Association and moved to this building on 56th Street in Kanawha City, where it still exists.

**SOUTH RUFFNER.** In the 1950s, South Ruffner was Charleston's fastest-developing section. Previously, the area south of the Kanawha River had a number of houses but little commercial development. The expansion began with Morris Harvey College's relocation to the South Side and the opening of Charleston Memorial Hospital. Many new businesses followed, including National Biscuit, Coca-Cola, Royal Crown Cola, United Fuel Gas (later Columbia Gas Transmission), and Chesapeake and Potomac Telephone (shown here). Additional improvements included Watt Powell Park, Imperial Towers, and railroad underpasses at Mission Hollow and Porter Hollow. A catalyst for much of this expansion was the South Side Expressway, which expanded MacCorkle Avenue to four lanes. It was completed entirely from the Patrick Street Bridge to Kanawha City in 1965.

**CHARLESTON CIVIC CENTER.** In November 1958, the Charleston Civic Center opened with a performance of *Holiday on Ice*. Promoted as the state's largest sports arena, the Civic Center accommodated approximately 6,000 for sporting events and 7,000 for concerts. The original facility was expanded with the addition of the Civic Center Coliseum in 1980. A controversy occurred shortly before the building's official dedication in January 1959. The Minneapolis Lakers were scheduled to play the Cincinnati Royals in a National Basketball Association game that marked the return of Charleston native and Lakers guard "Hot Rod" Hundley. After African American players were refused rooms at the Kanawha Hotel, Lakers star Elgin Baylor sat out the game in protest.

**HOLIDAY INN.** A 200-unit Holiday Inn opened on Kanawha Boulevard at the Elk River in 1964. The Holiday Inn was one in a series of chain hotels that brought about the eventual end for many downtown hotels such as the Ruffner and Daniel Boone. Ironically the Holiday Inn, with its nostalgic sign, also outlived its usefulness and was demolished in 2005.

**"THE BLOCK."** In 1966, the Heart O' Town Motel opened on Washington Street between Broad (now Leon Sullivan Way) and Shrewsbury Streets. This area previously was a thriving African American business district known as "the Block." A number of black-owned businesses fell victim to the urban renewal movement. G. E. "Cap" Ferguson's popular hotel, café, theater, and ballroom previously stood on the lot occupied by the Heart O' Town.

**NATIONAL BANK OF COMMERCE.** From 1924 to 1967, the National Bank of Commerce was located in the old Coyle and Richardson building at Capitol and Lee Streets. After the Capitol Annex was demolished, the bank constructed a 210-foot steel-and-glass structure on Lee Street between Hale and Dickinson Streets. This postcard is an artist's concept of the building prior to construction. It now is part of the Huntington National Bank system.

**CHARLESTON NATIONAL BANK.** In 1969, Charleston National Bank erected this 210-foot office building and parking building in the block bounded by the Kanawha Boulevard and Virginia, Capitol, and Summers Streets. The new Charleston National Bank building was the city's first glass-and-steel office building. It later was acquired by Bank One and Chase.

**STERNWHEEL REGATTA.** On Labor Day 1971, Nelson Jones held the first Sternwheel Regatta to honor Charleston's river history. The annual event later became a weeklong festival featuring national entertainers. A regatta fixture for many years was the *P. A. Denny* (center), one of the last remaining boats made by Charleston's Ward Engineering in 1930. (Photograph by Gary T. Truman.)

**INTERSTATE 64.** In 1973, a new bridge across the Kanawha River allowed Interstate 64 to be built through downtown Charleston. As times change, many things stay the same. Interstate 64 eventually connected Charleston with Norfolk, Virginia, and points westward, as the C&O Railway had done 100 years before. In downtown Charleston, engineers routed the interstate along virtually the same route the Ohio Central Railroad had taken in the 1880s.

# *Six*

# CHANGING LANDSCAPES

The postcards in this book depict an ever-changing portrait of Charleston. The style and location of buildings detail the growth and maturation of a city. From Edward Beyer's 1854 painting on page 12 to the 1970s aerial postcard on page 116, Charleston changed dramatically while retaining many distinctive features. In the intervening 120 years, the farms had vanished, tall buildings had replaced small houses and storefronts, and an interstate had been cut into the hillside. Still, in 1854 and 1973, Charleston essentially was a river city bounded by beautiful hills.

Some changes occur suddenly. In the blink of an eye, the 1921 capitol fire forever transformed downtown Charleston. Other developments, such as the growth of the East End, were much more subtle. Arguably not all the developments have been for the better. Many are the result of a city struggling to find its identity in a constantly changing world. This is part of an urban life cycle, and without adaptation, a city cannot survive. When the old gives way to the new, the best hope is that an envisioned plan will benefit the most people. When historic buildings are razed, the alternatives can be an office building that serves the community for the next 100 years or a little-used parking lot.

All historic buildings once were new, sometimes taking the place of another historic building. In the late 1930s, the 100-year-old Donnally-Goshorn house at the corner of Kanawha and Broad Streets was torn down and replaced with the United Carbon building, which now is listed in the National Register of Historic Places. A structure that seemingly is an eyesore at first may become the next generation's historic building. At the same time, some buildings embody residents' vision of a city. If the Union Building or old Kanawha Valley Bank building disappeared, would Charleston be the same place?

Like a time-lapse photograph, postcards tell a story over time. While browsing through these final postcards, think about how landscapes define our perception of Charleston.

The City from River, Charleston, W. Va.

**RIVERFRONT, 1907.** Before the days of high-rise buildings, many downtown Charleston landmarks were still visible from South Hills—the capitol, old customhouse, Charleston National Bank, and Kanawha Valley Bank. For decades, many buildings lined the riverbank and survived periodic flooding despite their precarious placement. A group of buildings that presently occupy 806 to 812 Kanawha Boulevard are barely visible in this postcard. These are the only structures along Kanawha Street in this postcard still standing.

CHARLESTON, W. VA. ON THE KANAWHA    4A-H1709

**RIVERFRONT, 1934.** Charleston begins to take on a familiar look with additions of the Union Building on the left and the Terminal, Security, and the new Kanawha Valley Bank Buildings in the distance. Several years later, this landscape would change again with the removal of all the buildings on the riverbank except for the Union Building.

**CAPITOL AND VIRGINIA STREETS, 1911.** This bird's-eye view of Capitol Street centers on the intersection with Virginia Street. The white building on the northwest corner (later known as the Cheers and other nightclubs) was an early home to the Scott Brothers Drug Store; here, it is the Capital City Bank. The postcard also shows the newly expanded Kanawha Hotel on the far left. The top of the capitol can be seen in the distance on the right.

**CAPITOL AND VIRGINIA STREETS, 1915.** Four years later, the landscape looks much different. The principal changes are the new federal building (currently the library)—only its roof is visible—and Security Building on the northeast corner. The Security Building, which housed Kanawha National Bank and Frankenberger's, now blocks the view of the capitol. The brick building on the southeast corner is one of Charleston's legendary businesses—Potterfield's Drug Store, which opened at this location just a few years before the postcard was published.

**CAPITOL AND QUARRIER STREETS, 1929.** This classic view of the 200 block of Capitol Street shows the Kanawha Valley Bank building shortly after its completion. On the far right corner is the Capital City Bank. Continuing down the right side is a series of clothing shops, including Schwabe and May. On the left are the Charleston National Bank, F. W. Woolworth's, and S. S. Kresge's. Dan Cohen Shoes, a new business, has moved into 217 Capitol Street beside the Fleetwood Hotel.

**CAPITOL AND QUARRIER STREETS, 1950s.** The buildings had changed little, but the storefronts had taken on the look many Charlestonians still remember. New businesses include the Whelan Drug Store on the near corner and Embees at its first location, 206 Capitol Street. Another notable change is Schwabe and May's move from Capitol Street to the corner of Quarrier and Hale Streets in the early 1930s. Other familiar sites include McCrory's and the A. W. Cox Department Store.

VIEW FROM SOUTH SIDE, CHARLESTON, W. VA.

**SKYLINE, 1916.** In the early 20th century, the area east of the South Side Bridge primarily was residential. Construction of Kanawha Boulevard in the late 1930s altered this scene forever. To widen Kanawha Street to four lanes, many of the old houses had to be demolished; others were placed on barges and moved to Kanawha City.

**SKYLINE, 1970.** The landscape in 1970 is dotted with high-rises and office buildings. Only a few of the old houses remain. New additions include, from left to right, the Charleston National Bank, United Carbon annex, United Carbon Building (now Boulevard Tower), First Presbyterian Church activities building, and the Riverview Apartments. The Union Building, Security Building, and Sacred Heart Co-Cathedral steeple are nearly the only common denominators between the two postcards. (Photograph by A. W. Harbrecht.)

**AERIAL VIEW, 1915.** These two aerial views show a striking transformation between 1915 and 1940. In 1915, the capitol is still located downtown, stores line both sides of Kanawha Street, the East End is entirely residential, and, in the distance, the Kanawha City Bridge has not yet been built.

**AERIAL VIEW, 1940.** Just 25 years later, Charleston has undergone many changes. After the 1921 fire, a new capitol was built on the East End. The destroyed capitol has been replaced by the Diamond and Kanawha Valley Bank. Kanawha Street had been expanded into the four-lane Kanawha Boulevard, eliminating all structures on the riverbank except the Union Building. In the distance, the Kanawha City Bridge has sparked the development of Kanawha City and South Ruffner.

THE LEVEE, 1960. The final two postcards depict how much Kanawha Boulevard's appearance changed in 10 years. Most of the buildings along the boulevard in 1960 had been built in the 1870s. Some of Charleston's longtime businesses began in these buildings—Schwabe and May, Palmer's Shoe Store, and Bass Jewelers. In the 1960s, the city initiated a massive urban renewal effort to remove obsolete buildings that did not meet modern codes. As a result, all of the buildings along the boulevard between the Union Building and courthouse were demolished. (Photograph by Jack Taylor.)

THE LEVEE, 1970. This photograph shows approximately the same view in 1970. The Charleston National Bank and parking building occupies the entire block between Capitol and Summers Streets. The Charleston House Holiday Inn encompasses the next block, between Summers and Laidley Streets. A fountain dedicated to late-mayor John Shanklin is at the corner of the Kanawha Boulevard and Court Street. In the far distance is another addition, the National Bank of Commerce building. (Photograph by C. H. Ruth.)

# INDEX

African Americans, 9, 14, 60, 79, 87, 95, 98, 109, 113, 114
H. G. Agsten and Sons, 102
Albright, Harrison, 39, 40
Ashton, Prentice, 68
Bank of Virginia, 9, 28
Banner Glass Company, 51
Baptist Temple, 39, 88
Barber, Dr. Timothy, 33
Bass Jewelers, 123
Beller, George, 100
Berman Jewelry, 80
Bigley School, 52
"Block, the," 114
B'Nai Israel Temple, 30, 56
B'Nai Jacob Synagogue, 56
Boggs, E. L., 42
Boiarsky, Abraham, 43
Boiarsky Memorial Hospital Association, 111
Boone, Daniel, 10
Boyd Memorial Christian Church, 78
bridges, 25
Brooks Music Studio, 44
Builtman, Walter, 74
Burlew, Noyes, 43, 68
Burlew Opera House, 68
Cantrell, W. A., 58
Capital City Bank, 119, 120
Capital City Commercial College, 27, 68
Capito, Charles, 100
Capitol Annex, 40, 66, 108, 115
Capitol Market, 32
Capitol (Plaza) Theater, 67

Catholic church, 29, 59, 70, 105
Central Junior High School, 35
Charleston Area Medical Center, 33, 37, 110
Charleston Business College, 27
Charleston Catholic High School, 105
Charleston City Hall, 26, 86
Charleston Cut Flower, 40
Charleston *Daily Mail*, 41, 49
Charleston Department Store, 44
Charleston General Hospital, 37, 71
Charleston Hardware, 58
Charleston High School, 24, 27, 35, 84
Charleston Memorial Hospital, 37, 110, 112
Charleston National Bank, 42, 48, 72, 79, 80, 115, 118, 120, 121, 123
Charleston Town Center, 58, 93, 109
Charleston Traction Company, 46, 51
chemical industry, 51, 75, 90
Chesapeake and Ohio Railway, 15, 25, 46, 50, 116
Chesapeake and Potomac Telephone Building, 112
Children's Home Society of West Virginia, 31
Christ Church United Methodist, 57
Citizens National Bank, 80
Civic Center, 49, 113
Civil War, 12, 16, 18, 23, 38, 92
Clay Center for the Arts and Sciences, 45, 64
Clendenin, George, 9
coal industry, 15, 22, 32, 63, 73, 81
Coleman, Edward J., 95
Columbia Barbed Wire and Nail Works, 76
Columbia Gas Transmission, 73, 112

Conley, William, 97
Cotton Block, 53, 61
Cox, A. W., 72, 93, 120
Coyle and Richardson, 27, 53, 58, 68, 72, 115
Coyle, George Fayette, 53
Craigo, J. M., 86
Crumb, George Sr., 44
Dan Cohen Shoes, 120
Daniel Boone Hotel, 94, 114
Daniels, F. J., 59
Davis Child Shelter, 31
Diamond, the, 83, 93, 122
Diamond Ice and Coal, 41
Dickinson Chapel, 16
Donnally, Andrew, 55
Dreamland Theatre, 57
Dunkirk Glass Company, 51
DuPont, 90
Edgewood, 46, 47
Eisensmith, Walter, 68
Elks Club, 36
Elliott, W. B., 27
Ellis, Jake, 100
Embees, 58, 120
England, E. T., 84
Episcopal church, 23
federal buildings (customhouses), 19, 63, 80, 118, 119
Ferguson Hotel, 114
Fernbank School, 65
fire department, 26, 49, 66, 82
First Baptist Church, 14
First Presbyterian Church, 18, 19, 66, 121
Fleetwood Hotel, 57, 120
Fort Hill, 92
Fort Lee, 9, 10
Frankenberger's, 54, 72, 119
Franklin Cafe, 100
Fredricks, Walter, 91
Friedman, Jacob, 44
Gallenberg, Ben, 43
Galperin Music, 44
gas industry, 63, 71
Gates, Charles, 42
Gates, Lovell, 43
Geary, Wehrle, 93
Germania Club, 36
Gilbert, Cass, 83, 96
Gilbert, Cass Jr., 90, 110
glass industry, 51, 77
Glenwood Athletic Club, 36, 47, 69

Glenwood School, 87
Goldbarth and Strauss, 42
Goshorn Brothers' Hardware, 58
Goshorn's Ferry, 12
Goshorn, Jacob, 55
Grady, James, 20
Grand Rapids Furniture, 58
Great Depression, 72, 81, 96, 97, 99
Greyhound Bus Station, 102
Greystone Hotel, 104
Guthrie, Morris, and Campbell Building, 88
Hale House, 23, 49
Hale, John P., 17, 23, 49
Harold, Bil, 101
Hawkins, Steele Sr., 46
Heart O' Town Motel, 114
Higgenbotham, Mamie, 38
Highland Hospital, 111
Hill, Arthur, 102
Hissom Tabernacle, 99
Holiday Inn, 54, 114, 123
Holley Hotel, 71
Holly Grove, 2
Hubbard Court, 64
Humphreys, James, 78
Humphreys Memorial Methodist Church, 78
Humphreys, Ray, 38
Hundley, "Hot Rod," 113
interstates, 32, 52, 109, 111, 116, 117
James River and Kanawha Turnpike, 11
Jan, Woo, 17
Jarvis, Anna, 97
Jefferson Junior High School, 87
Jelenko Brothers and Loeb, 58
Jelenko, Gustave, 28
Jewish immigrants and religion, 30, 36, 44, 54, 56, 59, 95
Jones, Nelson, 116
Kanawha (Yeager) Airport, 107
Kanawha and Michigan Railroad, 32, 41, 50, 61, 73, 116
Kanawha Banking and Trust, 58, 79
Kanawha Boulevard, 49, 55, 64, 81, 103, 121, 122
Kanawha City, 76, 77, 81, 111, 122
Kanawha Country Club, 96
Kanawha County Courthouse and Jail, 26
Kanawha Distilling, 42
Kanawha Hotel, 34, 113, 119
Kanawha Land Company, 51, 76
Kanawha Manufacturing, 73
Kanawha National Bank, 42, 72

Kanawha Presbyterian Church, 18
Kanawha School, 52
Kanawha Valley Bank, 28, 43, 83, 93, 117, 118, 120, 122
Kanawha Valley Hospital, 33
Kaufman's Clothing, 74
Kaufman, Grover, Harry, and Lawrence, 74
Kearse Theater, 85
Kelly Axe Factory, 98
Kenney, George, 84
Knight, Edward, 41
Kresge's, 120
Laidley Field, 89
Laidley, James M. and Rowena, 70
Levi, Mordecai, 17
Libbey-Owens Sheet Glass Plant, 51, 77
libraries, 40, 63, 66
Lincoln (Junior High) School, 62
Littlepage Terrace, 81
Loewenstein Brothers' Hardware, 58
Louden Heights, 92
Luna Park, 69
MacCorkle, William, 45, 51
Major, Floyd, 68
Martens, Robert, 104
Martens, Walter, 89, 104
Martin, George, 104
Masonic Temple, 29, 88
May Shoe Store, 43, 48
McCrory's, J. C., 60
McMillan Hospital, 71
Mercer School, 24, 35
Methodist church, 16, 18, 56, 57
Moore, S. Spencer, 42, 74
Morgan, Ephraim, 86, 89
Morris Harvey College, 40, 89, 108, 112
Morrison Building, 79
Morrison, O. J., 60, 68
Moses, S. A., 42
Mountain State Hospital, 84
Municipal Auditorium, 102
National Bank of Commerce, 53, 115, 123
National City Bank, 61
New York Central Railroad, 32
Newsome, Moses, 14
Nichols, I. E., 43
Nicholson, Hugh, 33
North Charleston, 22, 81
Nu-Way Cleaner, 74
Odd Fellows Building, 27, 68
oil industry, 63
Owens-Illinois Bottling Plant, 77

Palmer's Shoe Store, 123
Patrick Street Bridge, 98
Pauley's, 100
Peanut Shoppe, 80
Polan, Abraham, 43
police department, 86
post offices, 19, 63, 106
Potterfield's Drug Store, 119
prehistoric people, 9, 10
Presbyterian church, 18, 19
Quarrier Diner, 101
Rabenstein, Charles, 34
Rialto Theatre, 79
Richardson Brothers, 42
Richardson, J. Lynn, 53
Riggleman, Leonard, 108
Riverview Apartments, 121
Rock Lake Swimming Pool, 98
Roosevelt Junior High School, 87
Rose City Cafeteria, 101
Rose City Press Building, 88
Ruffner, Andrew and Meredith, 23, 49
Ruffner Brothers' Grocery, 49
Ruffner, Daniel, 2
Ruffner, Henry, 20
Ruffner Hotel, 23, 49, 91, 114
Sacred Heart (Co-Cathedral), Church of the, 29, 121
St. Albert Hotel, 17
St. Francis Hospital, 70
St. John's Episcopal Church, 23
St. Marks United Methodist Church, 16
salt industry, 9, 90
Satterthwait, Richard, 43
Schoenbaum, Alex, 98
Schwabe and May, 58, 120, 123
Sclove, Louis and Bertha, 95
Scott Brothers Drug Store, 55, 119
Scottish Rite Cathedral, 84
Security Building, 72, 88, 118, 119, 121
Shoney's, 98
Simpson Funeral Home, 33
Slack, William, 41
Smith, Henry, 61
Smith, Isaac, 41
Smith, Isaac Noyes, 76
South Charleston, 10, 22, 51, 75, 96, 98, 101
South Hills, 25, 45, 65, 105
South Ruffner, 81, 100, 108, 112, 122
South Side Bridge, 25, 65, 99, 121
Southern Mine Supply, 73
Spring Hill Cemetery, 59

State Street Methodist Church, 56
State Street Synagogue, 56
Staunton, Sidney and Susan, 41
Stenger, Father Joseph, 29
Sternwheel Regatta, 116
Sterrett Brothers, 42
Stone and Thomas, 7
Stonewall Jackson High School, 35, 105
Sullivan, Leon, 55
Sunday, Billy, 86
Sunrise, 45
Superior Laundry, 85
Terminal Building, 61, 118
Thomas, Dr. Frederick, 37
Tiskelwah School, 52, 62
Triangle district, the, 81, 109
Union Building, 64, 95, 117, 118, 121, 122
Union Carbide, 51, 75
Union Mission, 65
Union School, 27, 35
United Carbon Building, 55, 104, 117, 121
United Fuel Gas Company, 73
University of Charleston, 89, 97, 108
Veltri, Frankie, 71
Virginia Street Temple, 30
Ward Engineering, 14, 116
Warne, H. Rus, 34, 86
Washburn Hotel, 42
Washington, Booker T., 68
Washington Manor, 81
Washington Street Bridge, 38
WCHS radio, 91
West Side United Methodist Church, 78
West Virginia Governor's Mansion, 28, 89
West Virginia State Capitol, 2, 13, 20, 40, 81, 90, 96, 97, 110, 118, 122
   fires, 81–83, 90, 93, 94, 117
West Virginia Turnpike, 109, 111
Whelan Drug Store, 120
White Elephant Saloon, 72
Willis, N. N., 86
Wilson's Ferry, 12
Withrow, Pat, 65
Woodrum's, 7
Woolworth's, F. W., 66, 120
Yeager, Chuck, 107, 111
YMCA, 20, 54
YWCA, 35, 88
Young, Charles B., 85
Young, Otmer, Roma, and Walter, 101

# www.arcadiapublishing.com

Discover books about the town where you grew up, the cities where your friends and families live, the town where your parents met, or even that retirement spot you've been dreaming about. Our Web site provides history lovers with exclusive deals, advanced notification about new titles, e-mail alerts of author events, and much more.

**MADE IN THE USA**

Arcadia Publishing, the leading local history publisher in the United States, is committed to making history accessible and meaningful through publishing books that celebrate and preserve the heritage of America's people and places. Consistent with our mission to preserve history on a local level, this book was printed in South Carolina on American-made paper and manufactured entirely in the United States.

This book carries the accredited Forest Stewardship Council (FSC) label and is printed on 100 percent FSC-certified paper. Products carrying the FSC label are independently certified to assure consumers that they come from forests that are managed to meet the social, economic, and ecological needs of present and future generations.

**FSC**
Mixed Sources
Product group from well-managed forests and other controlled sources
Cert no. SW-COC-001530
www.fsc.org
© 1996 Forest Stewardship Council

*Find Your Place in History.*